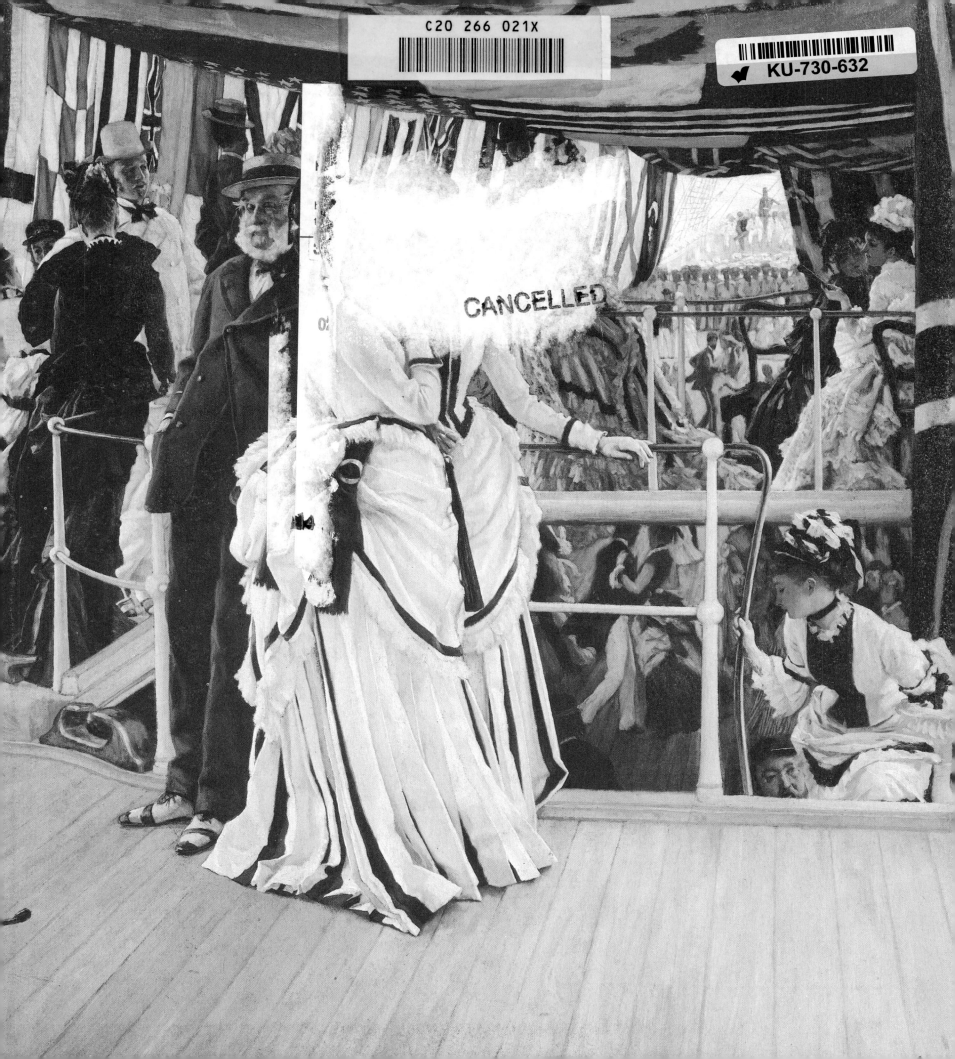

Tissot

Tissot

CHRISTOPHER WOOD

The Life and Work of
Jacques Joseph Tissot
1836–1902

WEIDENFELD AND NICOLSON
LONDON

By the same author

THE DICTIONARY OF VICTORIAN PAINTERS
VICTORIAN PANORAMA
THE PRE-RAPHAELITES
OLYMPIAN DREAMERS

Copyright © 1986 Christopher Wood
First published in Great Britain in 1986 by
George Weidenfeld and Nicolson Ltd

This 1995 edition published by
Orion Publishing Group, Orion House,
5 Upper St Martin's Lane, London, WC2H 9EA

ISBN 0 297 78930 9

Designed by Harry Green
Jacket designed by The Senate

Colour separations by Newsele Litho Ltd, Milan
Typeset by Keyspools Ltd, Newton-le-Willows, Lancs
Printed and bound in Italy

Frontispiece: *Boarding the Yacht*, 1873 (plate 62)
Overleaf: *Hide and Seek*, *c*1880–2 (plate 117)
Endpapers: *The Ball on Shipboard*, *c*1874 (plate 65)

Contents

Acknowledgments

All art books are, to some extent, a joint effort on the part of the author and the other writers, historians and dealers involved in the same period. This has been especially true of this book, and I could hardly have written it without the help and encouragement of three people – Michael Wentworth, Kristina Matyjaszkiewicz, and Jane Abdy. All three have made tremendous contributions to our present knowledge and appreciation of Tissot's work, and I am deeply grateful to all of them.

Many private collectors, dealers and museum curators have patiently borne my endless requests for photographs and information, and I thank them collectively, but none the less sincerely. Joanna Berry and Bridget Newbury typed my manuscript, and Juliette Avis handled much of the research and the correspondence. Barbara Mellor edited the text with exemplary thoroughness. To all of them my grateful thanks.

All my books seem to have been written in a surprising variety of locations. This one began at my School House in Somerset, continued at the London Library, then moved to Seymour and Julia Fortescue's house in the south of France, during a summer holiday. Finally, the book was finished in an unlikely spot, South Uist in the Outer Hebrides, on a fishing holiday with my mother and father, brother David and sister-in-law Sue, and their children John, Rosie and Robert Wood. This book is therefore dedicated to them all.

CHRISTOPHER WOOD
London 1985

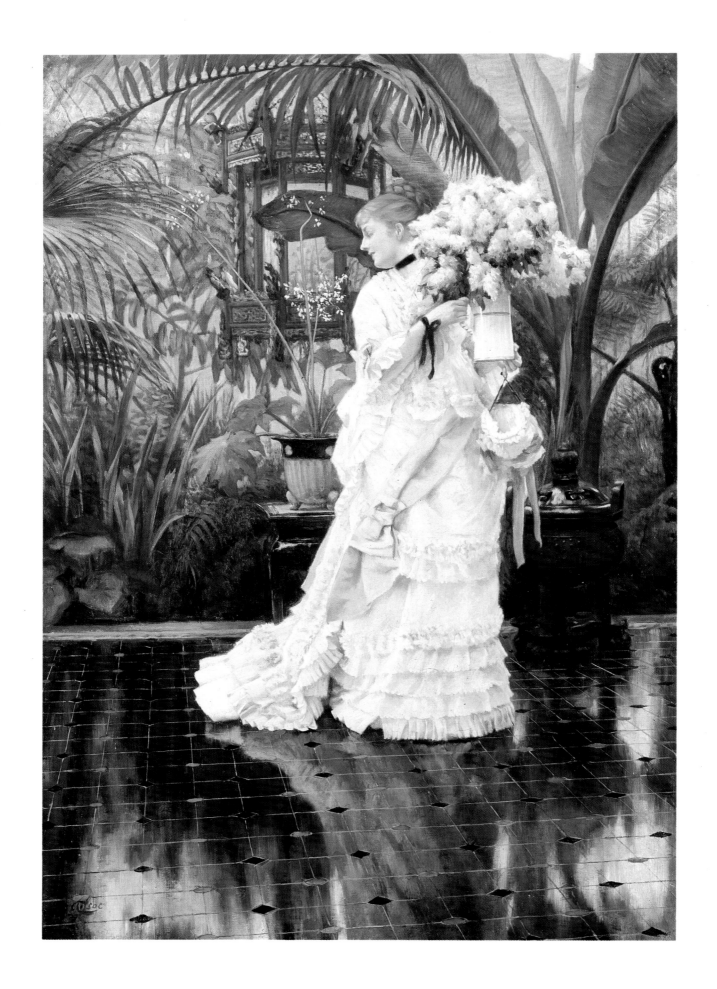

Introduction

Perhaps no nineteenth-century artist has benefited more than Tissot from the Victorian revival of the last twenty years. His reputation now stands higher than at any time since his death in 1902. He has been the subject of articles, books and several major exhibitions; his pictures regularly make six-figure sums in salerooms on both sides of the Atlantic. The reasons for this popularity are not hard to discover. Tissot was an assiduous and highly competent painter, most of whose pictures are of pretty, elegant women; his work is visually attractive, without being too demanding intellectually. It has also now acquired a tremendous patina of period charm, and is regularly, if sometimes inappropriately, used on book covers of Victorian novels. But there is a deeper reason; more than almost any Victorian painter of modern life, his pictures mirror exactly the habits and preoccupations of the age, and many of the tensions and contradictions that lay beneath its deceptively glossy surface.

The Bunch of Lilacs, c1875

Many more scholarly pens than mine have already written at length about Tissot. My aim in producing this book is to provide a readable, balanced survey of his whole career, omitting neither his early Paris years, nor his late religious phase, both of which are essential to an understanding of his complex character. I am fortunate in being able to support the text with over eighty colour plates, as well as black and white, and this is the first time Tissot's work has been reproduced on such a lavish scale.

I first became aware of the work of Tissot in the mid-1960s, nearly twenty years ago. At that time there were occasionally one or two of his pictures on view in the Tate Gallery. Two superb examples hung in the Guildhall Gallery in the City, where no one had bothered to take them down. Tissot's life and career, however, were still shrouded in total mystery. One knew that he was a French artist, who had lived for a period in London. He had had a mistress, who appeared in many of his pictures, and who had eventually died. He had then left London and turned to religious art, ending his days as a Trappist monk in a monastery somewhere in the French provinces. The myth about the Trappist monastery has proved an extremely hoary one, and still lingers in some quarters. Eventually I was able to acquire a copy of James Laver's rare and pioneering biography, published in 1936. Although full of errors and omissions, it remained the only available biography of Tissot for nearly fifty years.

I tell the story of my own discovery of Tissot because it is typical of the misunderstandings and misconceptions that still bedevil Tissot's reputation today. Most historians and critics still tend to dismiss Tissot's work as trivial and superficial. And yet Tissot is a minor master whose popularity is equal to that of many major artists of the same period. At a recent exhibition of his work in London the critics were in general cool and contemptuous, but the public poured in. Much the same thing happened in Tissot's own lifetime: his pictures of modern life were frequently attacked by the critics, but were popular with collectors, and sold for very high prices. Part of the reason for this ambiguity is the paradoxical nature of Tissot's own career. Although born a Frenchman and trained as a French artist, he came to London in mid-career. During his eleven years in London he enjoyed great artistic and financial success, and produced most of his finest work. He then returned to Paris, where, failing to re-establish his reputation, he became a religious artist for the rest of his career. The curiously Anglo-French character of Tissot's career, which is quite without parallel in nineteenth-century art, has been highly detrimental to a proper understanding and appreciation of his work. The English have tended to regard him as a Victorian narrative painter, completely ignoring all the French parts of his career. The French, however, have persisted in regarding him as a minor artist, and dismiss his work as too English. French chauvinism seems to dictate that a French artist who enjoys too great a success abroad is not easily forgiven. Perhaps only the Americans have been able to appreciate Tissot's work in all its diversity.

One of the greatest obstacles to understanding Tissot's work is what one might call the 'charm barrier'. Tissot's pictures have acquired for the twentieth-century viewer a tremendously thick layer of period charm. The contrast between the dazzling elegance and complexity of Victorian dress and the drab practicality of our twentieth-century attire must inevitably

arouse feelings of envy and nostalgia. But the charm of Tissot's pictures goes beyond mere appearances. He projects an image of an age infinitely more elegant and leisured than our own, in which people had the time to take tea in conservatories, picnic by ornamental pools, take trips down the river, and go to balls and concerts. Everyone looks distinguished, fashionable, aristocratic; butlers, footmen and maids hover dutifully in the background. We now see the Victorian world through hopelessly rose-tinted spectacles, just as the Victorians themselves romanticized about the eighteenth century and the Regency. But reading contemporary criticisms of Tissot's work brings one abruptly down to earth. It becomes at once apparent that the Victorians saw Tissot very differently. For Tissot's world was not that of the aristocracy, but of the newly-rich middle classes. Most Victorian painters of modern life had to face criticisms of vulgarity and lack of taste; with Tissot the criticisms were particularly shrill and violent, even from such distinguished writers as Oscar Wilde and Henry James. Even *The Ball on Shipboard*, the most ambitious and elegant of his social scenes, was dismissed as containing no 'real ladies'. For the Victorian viewer, Tissot's pictures represented the uneasy, even ridiculous world of the socially aspiring; people trying to look smart and ape the behaviour of their social superiors. Where we see only elegance and distinction, they saw merely vulgar, over-dressed people. The new plutocrats were a class the Victorians loved to hate, particularly during the 1870s and 80s, when newly-rich bankers, industrialists and merchants were steadily forcing their way into the jealously guarded world of the old aristocratic ruling classes. This resentment found expression in a wide variety of outlets, ranging from George du Maurier's cartoons pillorying the bloated plutocrat, Sir Gorgius Midas, to Melmotte the shady financier in Trollope's *The Way We Live Now*. It was a feeling which caused Tissot increasing difficulty with the English critics, and led to his withdrawal from both the Academy and Grosvenor Gallery exhibitions. Quite apart from the death of Mrs Newton, it may also have contributed to his decision to leave London in 1882.

The most common criticism of Tissot today is that he is a fashion-plate artist, a painter of pretty women, who loved to dwell on every detail of dresses, pleats, ribbons, bows and hats. Superficially this is certainly true. Had he lived today, Tissot would have made a superb fashion photographer. He had an eye for style and a feeling for chic. But if one begins to look more closely at Tissot's works, particularly at a whole exhibition of them, then it becomes apparent that there are much deeper, more disturbing under-currents beneath the surface. Except for the pictures of Mrs Newton and her children, which exude an atmosphere of genuine domestic happiness, most of Tissot's pictures project a mood of unmistakable tension and unease. His pretty heroines seem as lonely and frustrated as any in Victorian fiction. They gaze out at the spectator with stares full of suppressed restlessness and boredom, as if pleading to be rescued from the intolerable burden of their own beauty. Although apparently engaged in harmless and innocent diversions, they seem to be trapped behind the bars of an invisible cage. Tissot often uses the colours of the seasons and the weather to underline this surprisingly bitter mood; his pictures are full of autumn leaves and grey, leaden skies. His river scenes and dockside romances suggest not only the unhappiness of partings and departures, but a deeper mood of transience and

isolation. Even at balls and parties, very few of his characters seem to be enjoying themselves.

The predicament of Tissot's heroines is a reflection of the ambiguous and paradoxical situation of the Victorian woman. The position of a woman of a certain social standing was that of a pretty bird in a cage – ornamental, pampered, but trapped within a rigid moral and social code. In art, she might be a *femme fatale* or a 'Belle Dame sans Merci', but she still had no vote; she was 'The Angel in the House', but had no right to own property; she was a goddess, but could not get a divorce.

It is this psychological edge that gives Tissot's work its particular flavour, and raises it above the merely trivial. It separates him from the countless other minor nineteenth-century painters of domestic mini-dramas or keepsake beauties, and also partly explains his current popularity. If Tissot had genius, it was for depicting the life that he saw around him in a highly personal and individual way. Although a clever and accomplished painter, fundamentally he lacked the imagination necessary to create works of an allegorical or historical character. In spite of his great admiration for Burne-Jones, his own attempts at allegorical or mystical art were not a success, particularly in his late religious work.

Tissot's view of art was extremely literal, and he was best at simply painting what he saw. Like Courbet, he could not paint an angel because he had not seen one. More than most nineteenth-century artists, Tissot used the basic materials of his own life and surroundings to create his pictures, particularly during the period of his love affair with Kathleen Newton. It is therefore almost impossible to consider Tissot's life and his art separately. They overlap and intertwine continuously. Nowhere is this better illustrated than in the many photographs of Tissot, Mrs Newton and her two children, which were used by Tissot as the basis for composing pictures. Sometimes the poses are uncannily identical, as if both the photograph and the picture were produced from the same negative.

Because of Tissot's lack of imaginative ability, the range of his art is narrow, in spite of the many curious twists and turns of his career. Above all he was a painter of women, and the prototype of his female heroine, the forlorn, passive victim, was established at the very beginning of his career, with the Faust and Marguerite series. Every artist tends to have a central image, often repeated in different guises, through which he projects his deepest ideas and thoughts. In Tissot's case, his most enduring image was *la femme*, and those endless heroines with their immaculate dresses and their yearning, unhappy looks, are simply images of Tissot himself. He also tends to place his heroines in certain stock situations, which he often repeated. These situations are usually calculated to emphasise the mood of unease and tension he is trying to convey. Women therefore tend to be depicted as widows, orphans, convalescents, unhappy wives; in relation to men they are often involved in quarrels, tiffs, partings, rivalries. Usually, though, they are rather listlessly passing the time. Within this very narrow range of subjects, Tissot's treatment was extremely subtle, understated and witty. His narratives have a deft lightness of touch that makes Victorian narrative paintings seem laboured and pedestrian by comparison. That is not to deny that Tissot was at all influenced by Victorian painting. He was already aware of it before he came to London, and when he settled in England he

2 Edmond de Goncourt. Photograph from a painting by Félix Bracquemond.

proceeded to adapt his style to suit the English market, with brilliant success. Perhaps Tissot himself hardly knew what feelings he was trying to convey. Underneath all the charm and the elegance there clearly lurks a curiously bitter sensibility, which must reflect his own character and feelings, whether consciously or unconsciously. Because we do not know the answers, Tissot's pictures will always remain ultimately ambiguous or incomprehensible. Best perhaps to enjoy them for the visual feast they are.

Tissot left practically no writings about his art, except during his religious phase, when he was concerned to play down his earlier career as a painter of modern life. We are therefore forced to speculate about his ideas from our knowledge of his career, and from the visual evidence of the pictures themselves. This requires the skill of a psychologist allied to those of historian and novelist, but none the less it has to be attempted if we are to fathom the true subtlety and complexity of Tissot's art. And Tissot's character, like his painting, is full of ambiguity and paradox. He was a painter of modern life, yet devoted the last twenty years of his life to religious art. He loved women, yet never married. He became a religious recluse, but was also one of the most financially successful of all nineteenth-century artists. To most of his contemporaries he was an enigmatic, even baffling figure, and something of a cold fish. We owe much of our information about Tissot to the French writer Edmond de Goncourt (2), a caustic and sarcastic character whose observations about Tissot may have been somewhat tinged with dislike and envy. Nonetheless, his judgement of Tissot has remained the most widely quoted, and clearly reflects what his contemporaries felt about him: 'Tissot, this complex being, a blend of mysticism and phoniness, laboriously intelligent in spite of an unintelligent skull and the eyes of a boiled fish, passionate, finding every two or three years a new *appassionnement* [passion] with which he contracts a little new lease on life.'

Portraits of Tissot certainly tally with this description; in particular, the early self portrait (3) and the marvellously penetrating portrait of him by Degas (4). Photographs of him, whether in youth or old age, simply present the bland, dapper figure of a successful Victorian artist. Many of his contemporaries commented on the smartness of his dress. Even in the Holy Land, in search of Calvary or the Via Dolorosa, he would always be found in the most immaculate riding breeches. To the end of his life his clothes retained an impeccable English cut. This image of the successful Victorian artist, which stares out at us from so many photographs of the period, accords uneasily with our idea of the artist today. Tissot, like most Victorian artists, wanted to be thought of as a respectable member of society, and was happy to supply the kind of pictures the public wanted. He would have been pleased with a description of him by one interviewer, as 'a gentleman who might have been anything respectable'.

The key to Tissot's character may well lie in his religious upbringing. His mother was a Breton and a very devout Catholic, and Tissot was educated at several Jesuit seminaries. Like most educated Victorians he suffered from feelings of religious guilt: it is no accident that one of his favourite subjects was the prodigal son. Later in life, after his religious crisis, he tried to dismiss his past career and pretend that he had been a religious artist all his life. He wanted to see his career as that of a religious painter, interrupted by

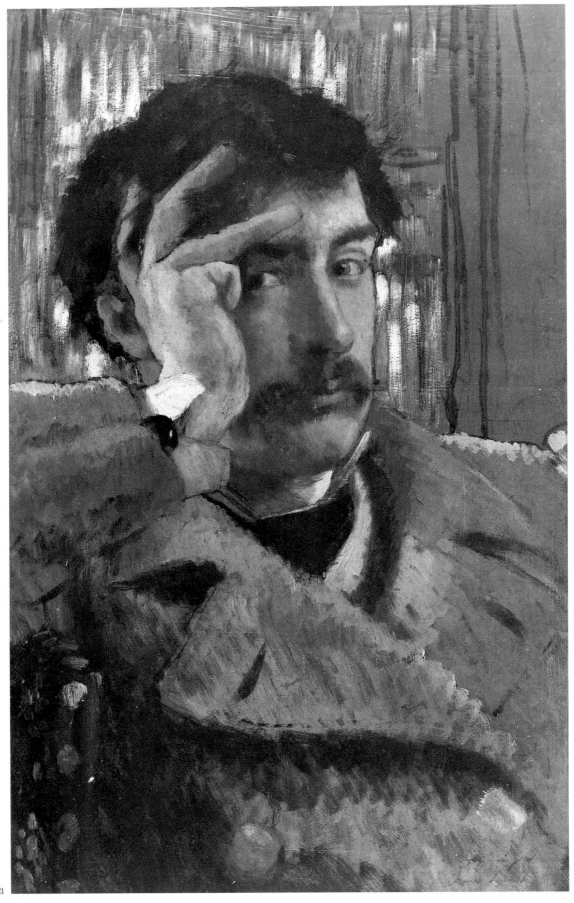

3

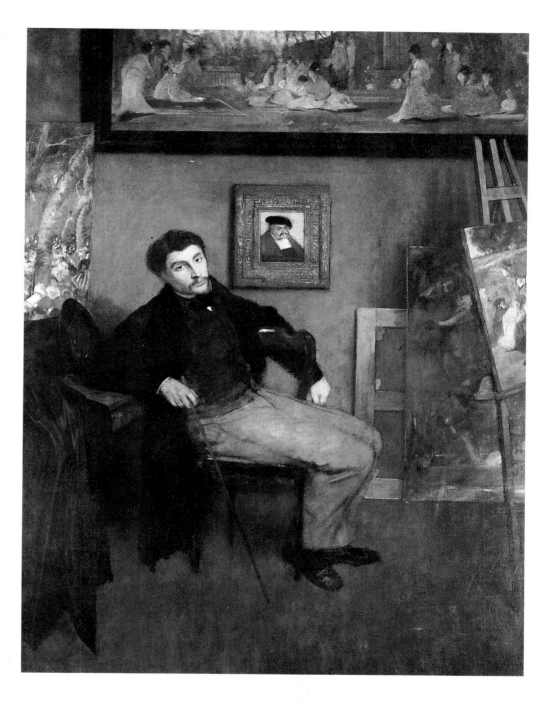

4 Edgar Degas (1834–1918),
Portrait of James Tissot, c1868.

3 Self-portrait, *c1865.*

a worldly phase. It is perhaps these uneasy feelings of guilt and disquiet that underlie his modern life pictures, and give them their curiously bitter-sweet atmosphere. But we can never be sure, because Tissot left no writings about these works. What we can be sure of is that Tissot is an utterly typical nineteenth-century figure, haunted by the religious doubts and fears that assailed so many of his contemporaries. Like many others, it led to dabbling in seances and spiritualism, and his eventual re-conversion to the intensely pious Catholic revival that dominated France in the 1880s and 90s. With his crystal ball and his visions of the Passion, Tissot is a typical Victorian figure, but paradoxically we admire his modern-life pictures and ignore his religious ones, a fact which would doubtless horrify Tissot if he could know. It is certainly wrong to ignore his religious work, even if it is artistically

inferior or less interesting, for in the wider sense his religious pictures are as much pictures of nineteenth-century life as are his *Femme à Paris* series. Both types of picture tell us a great deal about nineteenth-century France, for Tissot was a typical Victorian artist-antiquarian – he treated all subjects in the same laborious and literal manner, whether it was Faust and Marguerite, a ball on shipboard, or Christ on the cross. To the modern spectator, therefore, all these surprising phases of Tissot's career, these *appassionnements*, are of equal interest.

The greatest, of course, was Kathleen Newton, his English mistress, who appears in so many pictures between 1876 and 1882, and who is now threatening to become a cult figure in her own right. Certainly her brief and tragic life is all too typical of what must have happened to countless Victorian women who offended against the social code. Clearly she appealed strongly to something in Tissot's nature: with her frail health, haunting looks, and dubious past, she was transience personified, the very model of a Tissot heroine (5).

Both Tissot and Mrs Newton were Catholic, and could have married, but they preferred to live openly together, in defiance of Victorian morality, and for a few brief years enjoyed the nearest thing to domestic bliss that Tissot ever experienced. Eventually this happy interlude was brought to a tragic end, with Kathleen Newton's death from consumption in 1882. This caused Tissot's abrupt departure from London for good, and the end of his English career. For Kathleen Newton there remained the immortality achieved by so many artists' models of the Victorian age. It was her death that led to Tissot's involvement in spiritualism, and ultimately to his return to the Catholic fold. After his return to Paris he never married, in spite of one or two tragi-comic attempts at romance, and a broken engagement.

It was not only Kathleen Newton who inspired Tissot during his English period. He confessed that he found London itself stimulating: he loved 'the smell of smoke' and the sense of 'the battle of life' that it gave him. Arriving penniless from France in 1871, he faced an enormous personal and artistic challenge to which he rose magnificently, achieving far greater success in England than any of his French contemporaries. He was always sensitive to new ideas, and clever at absorbing them into his own style; and the way he forged a new style in England, combining Victorian subject matter with a French sensibility, is really his greatest achievement. During only eleven years in London, he developed a uniquely personal and individual style that is instantly recognizable, and quite without parallel in English art. His English pictures are the most admired today, and history is likely to endorse that view. Paradoxically, his very success in London alienated him from the French art world, and has affected his reputation in France ever since: he was only able to recover his position in France by a quite extraordinary second career as a religious artist. In England he only had one real disciple and that, surprisingly, was Atkinson Grimshaw, the painter of moonlight scenes. During the 1870s Grimshaw painted a number of pictures of ladies in aesthetic interiors which clearly owe a great deal to Tissot's example.

Technically, Tissot was a conservative and academic painter. The foundations of his style were laid in his early years as a historical painter and follower of the Belgian historicist, Henri Leys. That is not to say that he was not receptive to new ideas: his ability to absorb the artistic trends of the

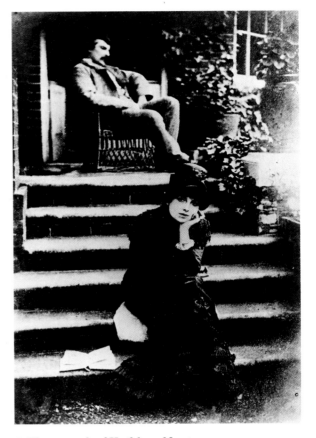

5 Photograph of Kathleen Newton.

day has already been mentioned. Japonisme, aestheticism, Impressionism, the vogue for the Directoire, Victorian narrative painting – Tissot flirted with all of them at different stages of his career, so much so that both de Goncourt and Whistler described him as a plagiarist.

Many attempts have been made to link Tissot's art with that of the Impressionists, in particular Degas and Manet, who were both friends of his, but comparisons of this kind are not particularly rewarding. He shares with them a preoccupation with the spirit of modern life, and an inevitable similarity of subject matter, but he was too innately conservative and prudent to become a wholehearted follower of the Impressionists, and he refused Degas' pressing invitation to join the Impressionist exhibition of 1874. There was always a streak of rather unattractive, hard-headed common sense in Tissot: anxious above all to succeed, he was afraid of committing himself too closely to rebel movements or advanced ideas. His method was to absorb the latest aesthetic ideas and techniques into his own style, toning them down into something both acceptable and saleable; this he did brilliantly, and was much more successful in his own day than any of the Impressionists. Posterity, however, has had its revenge.

His artistic position is therefore not easy to place. Technically, he belongs to the school of French academic painters, such as Meissonier or Gérôme, while managing to steer his own middle course between the academics and the Impressionists. But the idea of Tissot as merely a competent and assiduous minor master is no longer really tenable, for it fails to explain why a minor artist should enjoy such a major reputation. The real reason why his pictures so fascinate the twentieth century is that he was without doubt one of the most remarkable and original painters of nineteenth-century life.

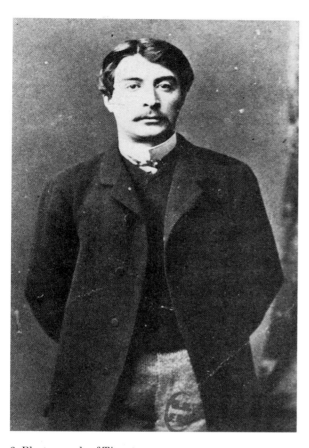

6 Photograph of Tissot as a young man.

NANTES AND PARIS
1836-1863

The Painter of the Middle Ages

Early Years 1836–1856

The story of Tissot's early years can be quickly told. He was born in 1836 in the town of Nantes, then a thriving seaport on the Loire estuary. His father Marcel Théodore was a prosperous merchant of the town, engaged mainly in the drapery business. The Tissot family, however, originally of Italian descent, were minor gentry from the area of Trévillers, a small mountain village in the Franche Comté, close to the Swiss border. It was here that Tissot's father was born in 1807, and from where he set out, like one of Balzac's provincial heroes, to seek his fortune. By 1845 he was successful enough to return in triumph to his native district, purchase a handsome estate, and live the life of a respectable country squire. The estate was the Château de Buillon, near Besançon, a plain but imposing house built in the eighteenth century, which Tissot *père* left to his painter son, Jacques Joseph, in 1888, and which was to play an important part in his later life. The château remained in the Tissot family until 1964.

7

Faust and Marguerite in the Garden
(*Faust et Marguerite au jardin*), 1861.

Tissot's mother, Marie Durand, was from Brittany, the daughter of an impoverished royalist family. She helped her husband in the drapery business, and was herself a designer of hats. Although Tissot himself never referred to it, his later passion for painting materials and fashionable ladies' dresses would certainly seem to imply a connection between his artistic career and his parents' involvement in the drapery trade, and there can be no doubt that he inherited from his father a shrewd business sense, which was later to make him one of the most financially successful of all nineteenth-century artists. From his mother he inherited another equally important trait, his devotion to the Catholic church. She was by all accounts extremely pious, and imbued him from an early age with those religious feelings which were later to change the course of his artistic life. All these childhood influences can be detected in Tissot's later career, but it was his father's practicality and realism in money matters that enabled him to put his upbringing to good use. Tissot's ability to reconcile piety with profits was of course typical of the Victorian self-made man, but in his case the excessive degree of the piety and the size of the profits were to cause wonder and amazement even among his contemporaries, and a great deal of envy from his fellow artists. Even Sargent, himself a successful artist, was to describe Tissot as 'a dealer of genius'.

Another influence on Tissot's career was the town of Nantes itself, at that time a major seaport, its quays thronged with shipping and merchandise from all over the world. Like all boys in the nineteenth century, the young Tissot must have felt that a great seaport was a place of adventure, mystery and romance, and his English pictures of ships and port scenes, painted over thirty years later, show such a complete mastery of the minute details of ships' rigging that he must have drawn on his boyhood recollections of the harbour at Nantes. The town also contained a wealth of medieval architecture, which fascinated Tissot as a boy. He showed an early taste for drawing gothic buildings, and at first wanted to be an architect. When he was sent to be educated at the first of three Jesuit colleges (where he proved neither a brilliant nor even a particularly able pupil) he took this passion with him; later he wrote that 'my desk was a perfect museum. Everthing was to be seen there, drawings, sculpture, architecture; a gothic belfry in wood, with an octagonal dome, a spire, bell-turrets etc.'

By the age of seventeen Tissot had already decided to become an artist. This caused the usual parental scenes which any student of the lives of nineteenth-century artists will recognize as distressingly familiar. Mary Cassatt's father, on hearing of his daughter's intended career, cried 'An artist! I would almost rather see you dead!' Atkinson Grimshaw's parents regularly threw his paints and brushes on the fire. Tissot's father was a keen amateur conchologist, but this in no way inclined him to approve of an artistic career for the second of his four sons. As usual, it was the mother who interceded for Jacques Joseph and who eventually overcame the father's objections. And so in 1856 or 1857 the twenty-year-old Tissot went to Paris to embark on his career as a painter. Like all sons of Victorian parents, he must have felt strongly the need to impress his father – even Frederic Leighton, later Lord Leighton and President of the Royal Academy, spent most of his life trying to convince his dry old doctor father that he was really becoming eminent. And in the end Tissot was to prove to his father that if he

could not be a businessman, he could be the most successful businessman that ever took up art.

Paris 1856–1863

Tissot's early training was typical of a nineteenth-century student's – academic, conservative and traditional. He studied briefly under Hippolyte Flandrin and for several years under Louis Lamothe, both pupils of Ingres. Lamothe, a modest character, sickly and melancholy, passed his life in the shadow of Ingres and Flandrin, never attaining the same degree of worldly success. His own pictures are almost completely forgotten today, but he was a good teacher, and will be remembered as the man who taught both Tissot and Degas (who often consulted him in later life). To Tissot he certainly bequeathed an exceptionally sound technique, that was to stand him in good stead for the rest of his career. Tissot was both a brilliant technician and a very good draughtsman, and these abilities, combined with a feeling for composition and structure, must in some part be due to Lamothe's training. Under Lamothe's guidance he studied both Italian and Flemish Primitives at the Louvre and copied them, visited Italy, and made drawings of classical sculpture.

The next logical step would have been for Tissot to study at the Ecole des Beaux-Arts, the French equivalent of the Royal Academy schools, as a prelude to eventually exhibiting at the Salon. During 1857 he appears to have studied briefly at the Beaux-Arts, but made little impression there. He obviously felt that he did not need the Beaux-Arts classes, and with typical assurance he already had his sights set on the Salon, where he exhibited his first pictures by 1859. One of these, *A Walk in the Snow*, shows a couple in medieval dress walking in the snow, and it already foreshadows the direction of Tissot's early style. Much more important to him than the tedious classes at the Beaux-Arts was the influence of his fellow artists.

One of these friends in Paris was James McNeill Whistler, whom he probably met when they were both copying the same Ingres picture in the Louvre. They were to remain friends both in Paris and London, until the Whistler-Ruskin trial of 1877, when Tissot refused to testify on Whistler's behalf. Through Whistler Tissot must have met several other French artists, such as Fantin-Latour, Alphonse Legros and possibly Courbet, but he also met several of Whistler's English friends, such as George du Maurier, Thomas Armstrong and Edward Poynter. These were the members of the so-called 'Trilby' gang, later to be immortalized by du Maurier's novel of that name. Contact with Whistler's flamboyant personality, and with his English friends, must have induced in Tissot an enthusiasm for all things English, for it was about this time that he changed his name to James, as he preferred to be known for the rest of his life.

Although their early works show very little superficial similarity, Tissot was extremely responsive to many of Whistler's ideas during this formative stage in his career. Technically and artistically, Tissot always remained conservative, but he displayed from the start an uncanny ability to absorb other artists' ideas and put them to his own use. He is known to have greatly admired Whistler's *Symphony in White no.3*, and Fantin-Latour warned Whistler that both Tissot and Alfred Stevens would imitate it. Later, in 1880,

Whistler wrote to his mother from Venice describing some pastels he had done of the city, adding 'Tissot I dare say will try his hand at once.' From Whistler Tissot must have acquired his later enthusiasm for Japanese art, and his interest in collecting Japanese objects and Chinese blue-and-white porcelain.

Two other important friendships were those with Degas and Manet. With Degas (8) Tissot was to have a long, difficult, and ultimately stormy relationship, which finally terminated in 1895 when Tissot sold a painting which Degas had given him. But for many years they corresponded, and during the 1860s and 70s, Degas was clearly fascinated by, and envious of, Tissot's tremendous success: it is difficult for us to realize that during this period, Tissot was by far the more successful of the two. Their letters reveal that the influence also went both ways, and Degas certainly owes much more to Tissot than has generally been recognized. Later Degas was to paint Tissot's portrait (4). The friendship with Manet was much more easy-going: they shared a love of good living and pretty girls, and were both ambitious for money and worldly success. They remained friends until Manet's death in 1883, and their close relationship certainly influenced both artists' pictures of moden life.

But it was his youthful craze for the Middle Ages that was to dominate the first years of Tissot's artistic output, from 1859 to about 1864. All his exhibits at the Salon between these years were historical or religious scenes, the majority from Goethe's *Faust*. In this he was following an already established literary and historical tradition, since the Middle Ages had for some time been a popular source of inspiration for artists and writers, finding expression in such books as Victor Hugo's *Notre-Dame de Paris*, (1831) and the novels of Sir Walter Scott, and in the historical paintings which throughout the 1840s and 50s were enormously popular both at the Royal Academy and at the Salon. The Pre-Raphaelite Brotherhood also formed part of this tradition, but their paintings of medieval and Shake-spearian scenes were distinguished by a fanatical devotion to detail and an added emotional fervour. In the 1850s it was modern to be medieval, and medievalizing influences can be found in the works of Gérôme, Delaroche, and Ingres at this period. But Tissot took as his example neither the Pre-Raphaelites nor his French contemporaries, but a now largely forgotten Belgian painter, Baron Henri Leys (1815–1869).

The works of Henri Leys enjoyed a tremendous reputation in the 1850s and 1860s, when the vogue for historicism, or the *style troubadour*, was at its height; indeed one of his pictures won a Gold Medal at the *Exposition Universelle* of 1855. Modelling himself on the early Flemish and German masters, Leys produced a new type of historical picture, highly romantic but at the same time monumental, combining an archaic style with carefully researched period detail in costumes and settings. The young Alma-Tadema also worked in Antwerp and was very much part of this movement, which made an instant appeal in Belgium to the growing national consciousness of a new country anxious to be reminded of its historical roots. Leys is still regarded as one of the fathers of Belgian painting, but it was not for this that Tissot admired his work. Leys' particular brand of historical romanticism, deliberately archaic and tremendously serious, even ponderous, made a profound appeal to the gothic imagination of the young Tissot, and was the

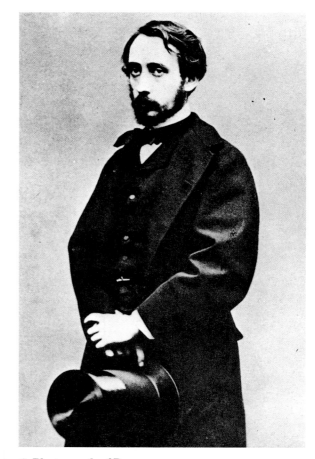

8 Photograph of Degas as a young man.

main inspiration behind all his early pictures, in particular the *Faust and Marguerite* series.

One of the pictures exhibited by Leys at the *Exposition Universelle* was *The Walk outside the Walls*, which, although he could not have seen it in 1855, Tissot must certainly have seen later. The subject of Faust and Marguerite was already popular in French art – Ary Scheffer, for instance, had made something of a speciality of it – to the extent that when Tissot exhibited his first Faust pictures at the Salon of 1861, one critic complained that 'poor Marguerite, eternal and banal victim of the painters of our times', should be left in peace. (Thackeray in a similar vein, had suggested in the 1840s that an entire room at the Royal Academy should be set aside for pictures of *The Vicar of Wakefield*.) Undeterred by the critics, Tissot devoted no fewer than seven pictures to Faustian themes in 1860 and the following year. These are entitled *The Meeting of Faust and Marguerite* (9), *Faust and Marguerite in the Garden* (7), *Marguerite at the Fountain* (10), *Marguerite on the Ramparts*, *Marguerite at Mass*, and two versions of *Marguerite in Church* (11).

Tissot's image of Marguerite owes far less to Goethe than to the

9 *The Meeting of Faust and Marguerite*
(*La Rencontre de Faust et de Marguerite*), 1860.

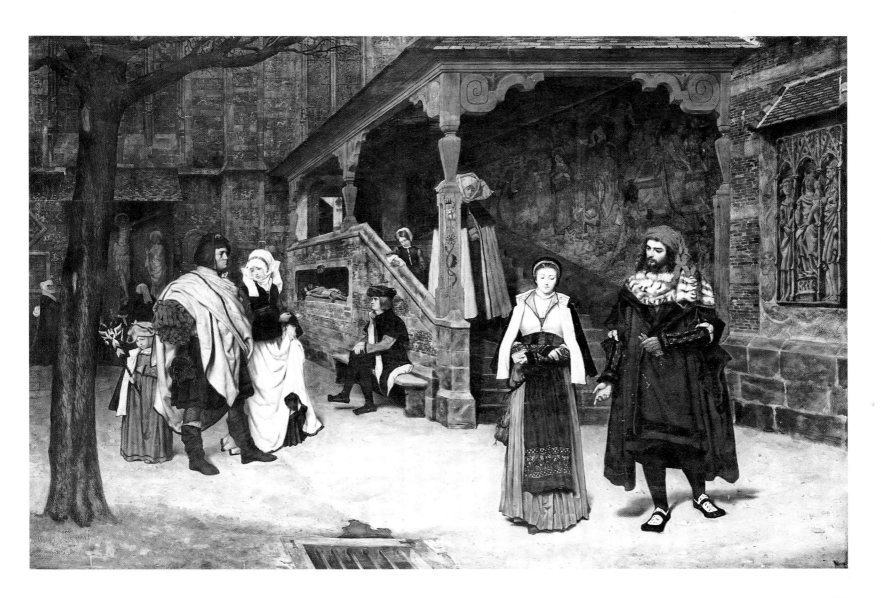

10 *Marguerite at the Fountain*
(*Marguerite à la fontaine*), 1861.

traditional French image of her as a romantic, doomed figure, a helpless
victim of her fate. In his pictures the interest centres on the brooding,
thoughtful figure of Marguerite, beautifully and richly adorned in her
medieval wardrobe. Already we sense – especially in *Marguerite at the
Fountain*, the direct ancestor of many of his late London pictures of
fashionable women – that Tissot has found the image that was to become the
leitmotif of his art: the single, brooding female figure. In all these early
works we find that sense of isolation and alienation in the figures that was to
remain a constant factor in his later work. The figures seem isolated from
one another, and there is a curious inability to separate them from the
background details. The critics were not slow to point out these weaknesses,
and the pictures met with a generally hostile reception at the Salon; the
historical style was already beginning to go out of fashion, and most critics
obviously felt it was a waste of Tissot's talents to devote himself to such an
outmoded style. His obvious debt to the works of Leys and the Pre-

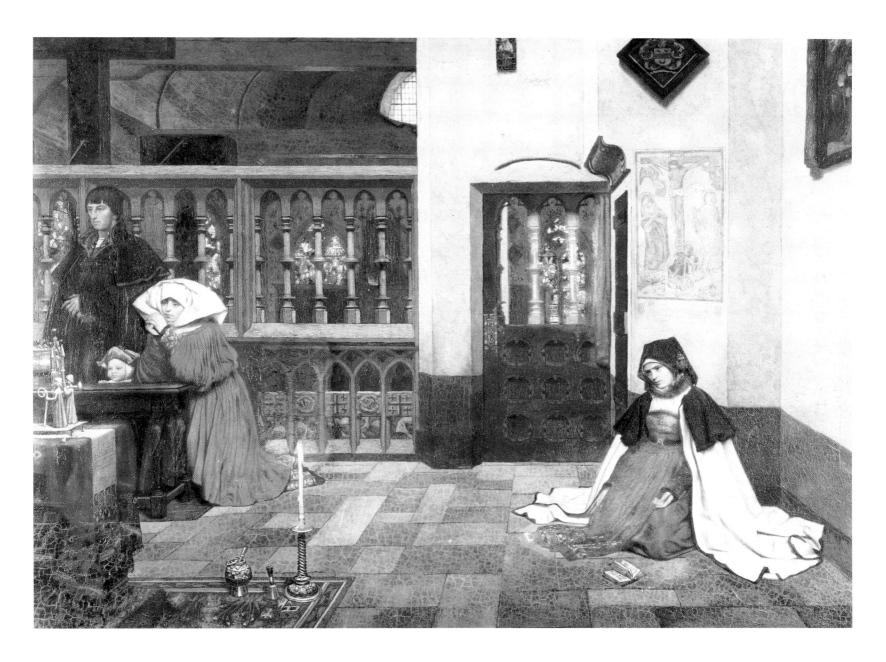

11 *Marguerite in Church*
(*Marguerite à l'église*), c1860.

Raphaelites was recognized, but dismissed as mere clever pastiche. One critic called it 'the apotheosis of curiosity, and the triumph of *bric-à-brac*'. Other faults, such as hard colour, lack of perspective, and obtrusive detail were also noticed. One is reminded of similar criticisms levelled at the Pre-Raphaelite Brotherhood ten years earlier, in particular the *Illustrated London News* critic who described the PRB as 'practitioners of "Early Christian Art" … who setting aside the medieval schools of Italy – the Raffaeles, Guidos and Titians, and all such small-beer daubers – devoted their energies to the reproduction of saints squeezed out perfectly flat.' Nevertheless one of the first of the Faust pictures *The Meeting of Faust and Marguerite* (9) attracted the attention of an important patron, the Comte de Nieuwekerke, who arranged for it to be purchased by the State for the Musée de Luxembourg. For an artist still in his mid-twenties, who had not yet won any kind of Salon award, this was a remarkable triumph.

These early medieval pictures have less appeal to the modern viewer,

however. Like his later religious works, they come as something of a surprise to those accustomed to think of Tissot as a painter of society. Their colouring is hard and sombre, with blacks, browns and greys predominating, and the subject matter seems remote and incomprehensible to our eyes; indeed the whole historicist movement of the 1830s and 40s is still largely ignored by present-day historians and collectors. Similarly, English histor- ical pictures of the 1840s and 50s, except those of the major Pre-Raphaelite figures, have not shared in the general revival of popularity of Victorian art. The historical works of Frith, for example, are considered far less valuable and interesting than his modern-life pictures, even though he used almost indistinguishable techniques and methods in both styles. Much the same applies to the early pictures of Tissot: their technical virtuosity is admired – they are certainly remarkable *tours de force* for a young painter – but they

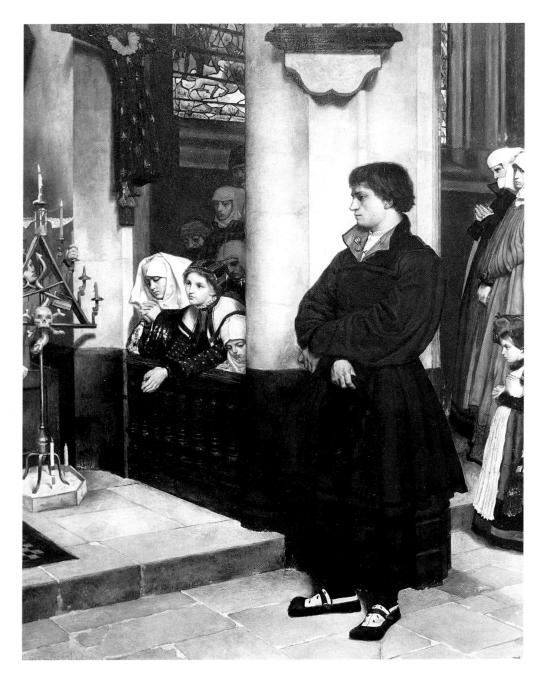

12 *Martin Luther's Doubts* (*Pendant l'office*), 1860.

THE PAINTER OF THE MIDDLE AGES

are not nearly so highly regarded as his later pictures. But they are interesting despite their unfamiliar subject matter because of the clear way in which they prefigure the direction of the artist's later development. When he came to paint modern-life pictures Tissot, like Frith, was to apply exactly the same methods and techniques as he had in his early medieval pictures; indeed throughout its many different phases, Tissot's work remained remarkably consistent. In spite of the critics, he persevered with historical pictures in the Leysian style from 1861 to 1863, exhibiting two other historical pictures at the Salon in 1861: *Martin Luther's Doubts* (12) and *Way of Flowers, Way of Tears* (13). The Luther subject was also clearly inspired by Leys, who had painted *Luther Singing in the Streets of Eisenach* only two years before. Tissot places Luther, like the isolated figure of Marguerite, alone and brooding beside a pillar in a church, cutting him off from the

13 *Way of Flowers, Way of Tears*
(*Voie des fleurs, voie des pleurs*), 1860.

congregation in the background, a compositional technique often used by Leys. Tissot also used it throughout his career, to convey the mood of isolation and alienation that underlies all his art. Religious doubt is not an easy thing to depict on canvas, but Tissot has managed to do it more seriously and successfully than many of his contemporaries: *The Doubt – can these Dry Bones Live?*, for instance, by Thomas Bowler, a minor Pre-Raphaelite painter, simply shows a pretty girl leaning on a tombstone.

Way of Flowers, Way of Tears is an elaborate and moralistic dance of death in the Leysian manner, but which owes more to Holbein and German painting of the fifteenth century; it was the only one of Tissot's early works to be admired by the critics, and received a long explanatory review from Théophile Gautier. Although distinctly stagey and theatrical to twentieth-century eyes, it is a remarkable composition, with the figures silhouetted on a hillside, and the weird skeletal figure of Death bringing up the rear, carrying a coffin. Even Degas thought it worth sketching in one of his notebooks.

Doubtless encouraged by this success and the purchase of his *Faust and Marguerite* picture for the Luxembourg, Tissot went on to paint three more large historical pictures, all exhibited at the Salon of 1863, which in scale and elaboration exceeded anything he had done before. These were *The*

Departure of the Fiancée, The Return of the Prodigal Son (14) and *The Departure of the Prodigal Son from Venice* (16). *The Departure of the Fiancée*, now lost and known only through prints, belongs spiritually to the *Faust and Marguerite* series. *The Return of the Prodigal Son* is a much more remarkable picture, and may be considered as Tissot's final defiant fling in the Leysian style. By setting a biblical subject in an elaborate stage-set of medieval buildings he simultaneously gave the narrative an added piquancy and aroused the further wrath of the critics. Criticism of his Leysian mannerisms intensified, and the picture was satirized in a cartoon, in which a skinny prodigal in exaggerated medieval costume pleads with his father that Tissot is making him ridiculous. When it was shown in London, at the Society of British Artists in 1864, the English critics were unimpressed. The *Athenaeum* thought it 'affected, false and artificial' and castigated Tissot for wasting his talents by imitating 'so bizarre a school of painters as that of ancient Flanders'. At last, perhaps because of these criticisms, Tissot decided to abandon the Middle Ages and turn instead to modern life. But the subject of the prodigal son continued to fascinate him, and he was to return to it (set in modern dress) in the 1880s. Seemingly Tissot identified strongly with the prodigal, and used the subject to express his own feelings of religious guilt.

The Departure of the Prodigal Son from Venice (16), a large and elaborate costume piece in the manner of Carpaccio, was the third picture exhibited at the 1863 Salon. Tissot is known to have travelled to Italy in 1862, visiting

14 *The Return of the Prodigal Son*
(*Le Retour de l'enfant prodigue*), 1862.

15 *The Promenade on the Ramparts*
(*Promenade sur les remparts*), 1864.

16 *The Departure of the Prodigal Son from Venice*
(*Le Départ de l'enfant prodigue à Venise*), *c*1863.

17 *The Elopement* (*L'Enlèvement*), *c*1865.

Milan, Florence and Venice, where he was much impressed by the Italian
primitives. This was a short-lived enthusiasm, however: the Venice picture
is unique in his work and he never returned to the Italian style, though he
did continue to produce occasional medieval works, such as *The Elopement*
of *c*1865 (17), a mannered but brilliantly executed elopement scene set in the
sixteenth century. Although Tissot was to achieve greatness and fame as a
painter of modern life, the importance of his medieval phase cannot be over-
emphasized. The influence of Leys and the Middle Ages left an indelible
mark on both his style and his technique, and was to give his modern-life
painting its unique character.

PARIS
1864-1871

The Painter of Modern Life

At some time in about 1863 Tissot must have made the decision to abandon the medieval style: the first (but not the last) abrupt change of direction in his career. He first attempted to come to terms with modern life in portraits – figure subjects came a little later – and having abandoned Leys and the Middle Ages, his work becomes subject to a new set of influences. As Tissot's modern style begins to develop, we can clearly see him absorbing these influences, and moulding them into his own personal style.

18
Portrait of Mlle L. L. . . . , 1864.

19 *The Two Sisters; portrait*
(*Les Deux Soeurs*), 1863.

At the Salon of 1864 Tissot exhibited two remarkable portraits, the por-
trait of *Mlle L.L.* . . . (18) and *The Two Sisters* (19), both of which show him
adapting to the modern style with extraordinary panache and assurance.
The picture of *Mlle L.L.* . . . was an immediate success, and remains one of his
finest and most admired portraits. The pose has an easy, unforced nonchal-
ance, and the enigmatic gaze of the young girl is arresting and intriguing.
The composition is also striking and typical of Tissot, the figure being placed
in a very shallow setting with the chair and other objects abruptly cut off by

the picture's edge. Tissot's love of fashionable dress is foreshadowed in the red 'bolero' with the bobble-fringe, part of the vogue in the 1860s for all things Spanish, which was given a boost by the Empress Eugénie, herself a leader and arbiter of fashion. The art historian can point to many obvious influences and parallels, particularly from the work of Ingres, Courbet and Degas, but the outstanding quality of this portrait is its assurance and maturity. It shows how Tissot was able with astonishing ease and rapidity to switch his style from medieval to modern. The critics were impressed, and Thoré in his review of the 1864 Salon praised the 'sincerity of its modern sentiment'. *Mlle L.L....* obviously struck the contemporary viewer as a thoroughly modern young lady. With her bold stare and the clutter of books beside her, she exudes an atmosphere of independence and informality that is equally fascinating to the twentieth-century viewer. She is the first of Tissot's many memorable images of the nineteenth-century woman.

The Two Sisters attracted an even greater share of critical attention. A large and handsome picture of two girls in white standing by a stream, it was much praised for its stylish elegance and naturalness. The green tones of the girls' faces earned them the soubriquet, 'the green ladies', which was not so much a criticism as a recognition that Tissot was beginning to overcome his old problems with local colour and overall tonality. The technique is considerably looser and broader than his early Leysian pictures, and the two girls blend much more naturally with their surroundings. The picture owes an obvious debt both to Courbet and to Whistler's *White Girl*, which Tissot is known to have greatly admired, and which was exhibited at the Salon des Refusés in 1863. Both Tissot and Whistler were influenced by the earthy realism of Courbet, and Tissot's *The Two Sisters* clearly reflects the influence of Courbet's *Young Ladies on the Banks of the Seine*. Tissot, however, has given his young ladies an air of style and good breeding quite alien to the brash vulgarity of Courbet's women.

Through Whistler, Tissot was also beginning to imbibe some of the latest trends in English painting. Whistler had settled in London in 1859, where he became a friend and neighbour of Rossetti, who lived further along the river from him in Chelsea. Whistler was much impressed by Rossetti's new aesthetic ideas about art as decoration and the unimportance of 'subject' in painting, which contributed greatly to the development of his style, and later furnished him with many of the aesthetic theories put forward in his notorious 'Ten O'Clock Lecture' of 1885. Whistler was also impressed with the later Pre-Raphaelite paintings of Millais, such as *Autumn Leaves* (1855) and *The Vale of Rest* (1858), which were beautiful, but without having any specific subject or narrative interest. In Tissot's Salon picture of 1865, *Spring* (20), the influence of Millais becomes overwhelmingly obvious, and its clear similarity to *Spring* or *Apple Blossom* of 1859 was much remarked upon. But while the subject is superficially very similar, Tissot has tried to make it his own by combining Millais' poetic mood with the bolder realism of Courbet's *Young Ladies*.

By 1866 Tissot was succumbing to yet another *appassionnement* – Alfred Stevens, a Belgian artist (who in England is continually confused with the sculptor of the same name). As artists they could hardly have been more different. Stevens acquired a tremendous reputation in the 1860s as a painter of pretty, well-dressed girls. His chic little Parisiennes do very little except

20 *Spring (Le Printemps)*, 1865.

read, talk or gossip, though for added piquancy they sometimes hold Bibles and look endearingly penitent. But above all they are always beautifully dressed, managing to look both stylish and respectable even if they are only courtesans. And like Tissot, Stevens was technically a highly accomplished painter, who was able to depict the details of his girls' dresses and their surroundings with dazzling brilliance. Tissot must have felt an immediate affinity with Steven's pictures, for he began to imitate them closely and with conspicuous success. The results can be seen in two of his Salon pictures, *The Confessional* (21) of 1866, and *Young Lady singing to the Organ* (22) of *c*1867. He seemed particularly attracted by the irony of putting his pretty, smartly dressed girls in church, a trick also used by Stevens; but a comparison with the earlier pictures of Marguerite in church show how far he had moved on. Instead of the rather earnest attempts to convey religious sincerity in the Marguerite pictures, Tissot allows his ladies of the 1860s to be almost entirely decorative. After this, he gave up religious subjects, except for the prodigal son series, for nearly twenty years, until, in the last

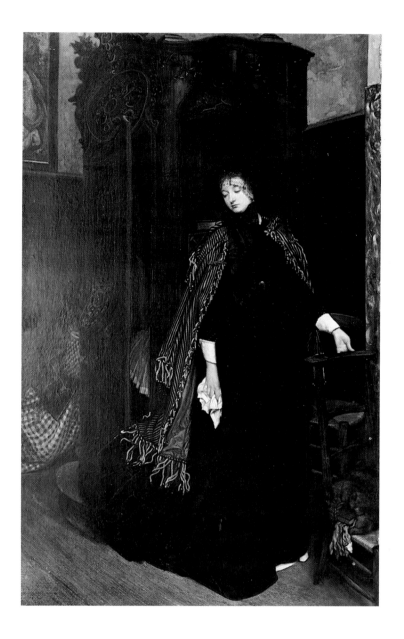

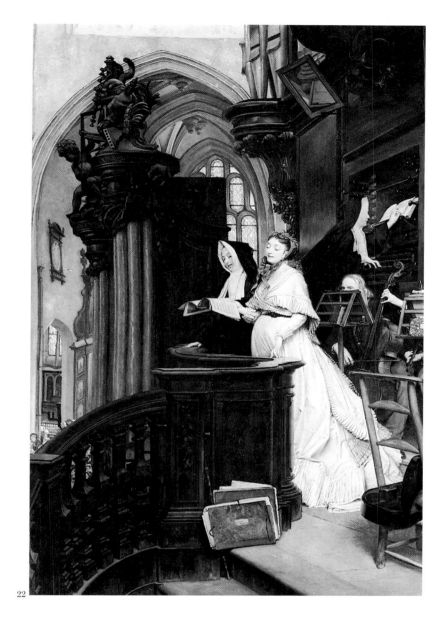

21 *The Confessional (Le Confessional)*, 1866.

22 *Young Lady singing to the Organ*
(*Jeune Femme chantant à l'orgue*), c1867.

picture of the *Femme à Paris* series, painted in the 1880s, he showed a fashionable lady singing in an organ loft. Curiously, it was while he was painting this picture that his religious crisis occurred.

The success of these modern-life subjects led to a number of important portrait commissions, including several family portraits for the Marquis de Miramon. This in turn led to the most important commission of Tissot's early career, *The Circle of the rue Royale* (23), showing a group of twelve men on a balcony looking over the Place de la Concorde. The Marquis belonged to this small and exclusive club, but the only member remembered today is Charles Haas, who steps out of the doorway to the right, and on whom Proust based the character of Swann in *A la Recherche du Temps Perdu*. Proust also refers to the portrait in his book, rightly recognizing it as a uniquely successful image of social life under the Second Empire. For some it is Tissot's masterpiece. Unquestionably, it is the finest group portrait he ever painted, and it is a pity that he did not receive more such commissions. The composition is striking, the grouping of the figures masterly, and the

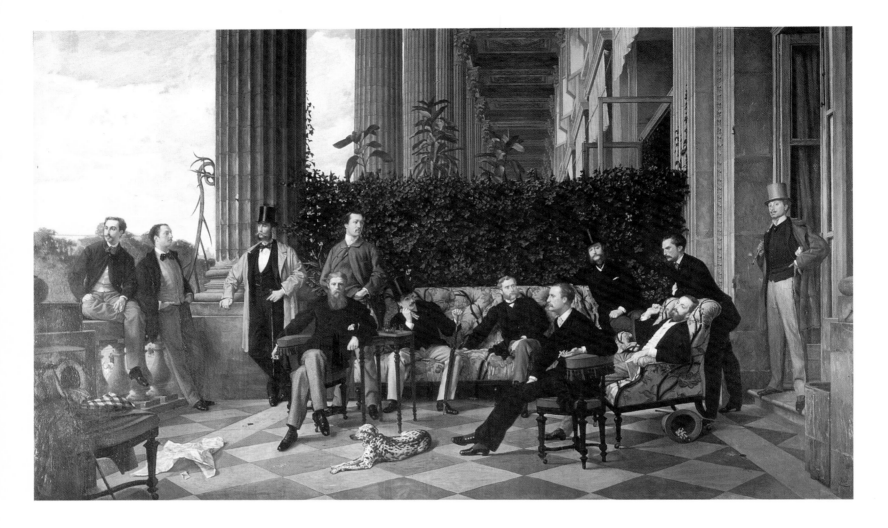

23 *The Circle of the rue Royale*
(*Le Cercle de la rue Royale*), 1868.

poses both psychologically telling and entirely natural. The sitters look as if they were merely posing for a photograph, and it is likely that Tissot made use of photographs in completing so many portraits in one picture. The secondary detail, mostly typical of a men's club – newspapers, hats, gloves, canes, cigarettes – is also beautifully observed, and in no way disturbs the composition. Tissot was always remarkably good at male portraits, as is evinced by the smaller *Eugène Coppens de Fontenay* (24) which dates from the same period. Once again the pose of this elegant and self-satisfied young man is effortlessly natural, as he lolls against the mantelpiece in his obviously very opulent drawing room. It is another outstanding period piece – the spirit of the Second Empire on canvas.

By this time Tissot too had moved to more opulent surroundings. Between 1866 and 1868 he built himself a handsome house at 64, avenue de l'Impératrice, one of Haussman's new avenues leading from Etoile to the Bois de Boulogne, whose most striking feature was the studio. Decorated in the very latest Japanese fashion, it was much talked about, and written up in the newspapers. Doubtless the crusty old parent down at Buillon was now persuaded that his son was on the road to prosperity. Although Tissot was highly fashion-conscious, his own lifestyle was relatively modest and domesticated for he seemed to prefer the company of a few artist friends to the glamour of the Salons. A self-portrait of the mid-60s (3) gives us a good picture of the artist at this time, combining fashionable nonchalance with

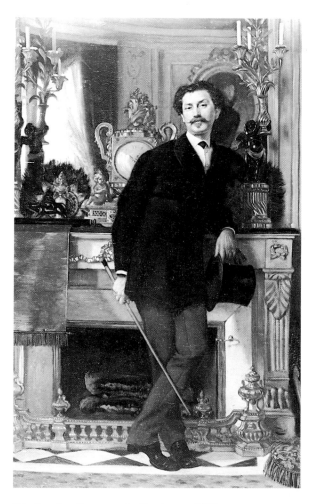

24 *Eugène Coppens de Fontenay*, 1867.

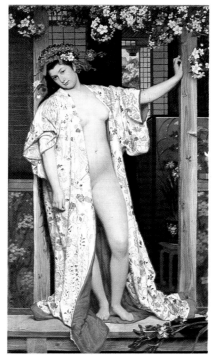

25 *Japanese Girl Bathing*
(*Japonaise au Bain*), 1864.

rather intense self-questioning. Even more penetrating is the portrait painted by Degas at this period (4). Here the awkward leaning pose gives a distinctly unstable atmosphere to the picture, and brings to mind de Goncourt's description of Tissot in his *Journal* of 1890 as 'laboriously intelligent, in spite of an unintelligent skull and the eyes of a boiled fish'. Both Degas and de Goncourt were mystified by Tissot, and undoubtedly jealous of his success. In their letters and journals they rarely have a good word to say about him.

The influence of Japanese art is an important ingredient in the evolution of Tissot's style in the 1860s. He was already a well-known collector of Japanese art by 1864, as is recorded in a letter from Rossetti to his mother in November 1864, in which he wrote that he had visited a shop, probably Madame Desoye's in the rue de Rivoli, in search of Japanese objects, but 'I have bought very little – only four Japanese books . . . I went to his Japanese shop but found all the costumes were being snapped up by a French artist, Tissot, who it seems is doing three Japanese pictures, which the mistress of the shop described to me as the three wonders of the world, evidently in her opinion quite throwing Whistler into the shade.'

One of these three pictures was almost certainly the *Japanese Girl Bathing* (25) of 1864. This was Tissot's first attempt at a Japanese subject, and the result is a curiously paradoxical image of an obviously Parisian model decked out in a kimono and other Japanese accessories. It reflects the influence of Courbet as much as of Japan, and merely transposes one of Courbet's voluptuous maidens from the Seine to the bathroom, wearing a Japanese kimono. The result is an uneasy, vaguely pornographic image, which cannot be accounted one of Tissot's most successful works, although it is his only large female nude. As an attempt to blend East and West it cannot be compared with Whistler's wonderful *Princess of the Land of Porcelain* (27) also of 1864, and exhibited at the Salon of 1865, which Tissot obviously had in mind when he painted his next Japanese picture, the *Young Lady holding Japanese Objects* (26) of 1865. Here Tissot has taken the genre one step further by introducing a Japanese model, probably taking her head from a Japanese doll, and Japanese objects, perhaps from Tissot's own collection, which she is shown examining in a conservatory. Once again the Japanese element merely reflects a fashion in western taste and shows no understanding of Japanese art itself. Tissot lacked Whistler's appreciation of the importance of Japanese design and composition, and was only interested in depicting the superficial aspects of Japanese art. This attitude is shown even more clearly in his later Japanese pictures of the 1860s, one of which was exhibited at the Salon of 1869 (28). All of these simply depict fashionable young ladies looking at Japanese objects, applying the Stevens formula to the Japanese vogue. Stevens himself painted numerous pictures of a similar type, but it was Tissot who made the genre his own. His young ladies are even prettier and more chic than those of Stevens, and his collection of Japanese objects was more interesting and varied. To our eyes these pictures are delightful Second Empire period pieces, like Tissot's portraits, and they have acquired a layer of period charm. The critics, however, beginning to tire of the Japanese vogue, were generally scathing about Tissot's Japanese pictures. One described them as Japanese objects looking at young ladies, and another complained that the objects played a

considerably larger role than the people – certainly a justifiable criticism, as the paintings are basically trivial, and deliberately so, making no serious demands on the viewer's intellect. The formula was also imitated endlessly by other Parisian artists, and the critics were understandably losing patience with these innumerable little dramas of flirtation amid the Japanese bric-à-brac. But, superficial as they are, Tissot's smart Japanese pictures were his most notable contribution to the genre, and made an undoubted impact on French taste in the 1860s. It was only later in London that he explored the wider possibilities of Japanese art, attempting to blend it more completely with his own style. In the 1860s he was simply exploiting a fashionable fad with considerable success, as his grand house and studio amply demonstrated.

In 1868 Tissot's position as the painter *par excellence* of *japonaiserie*

26 *Young Lady holding Japanese Objects* (*Jeune Femme tenant des objets japonais*), 1865.

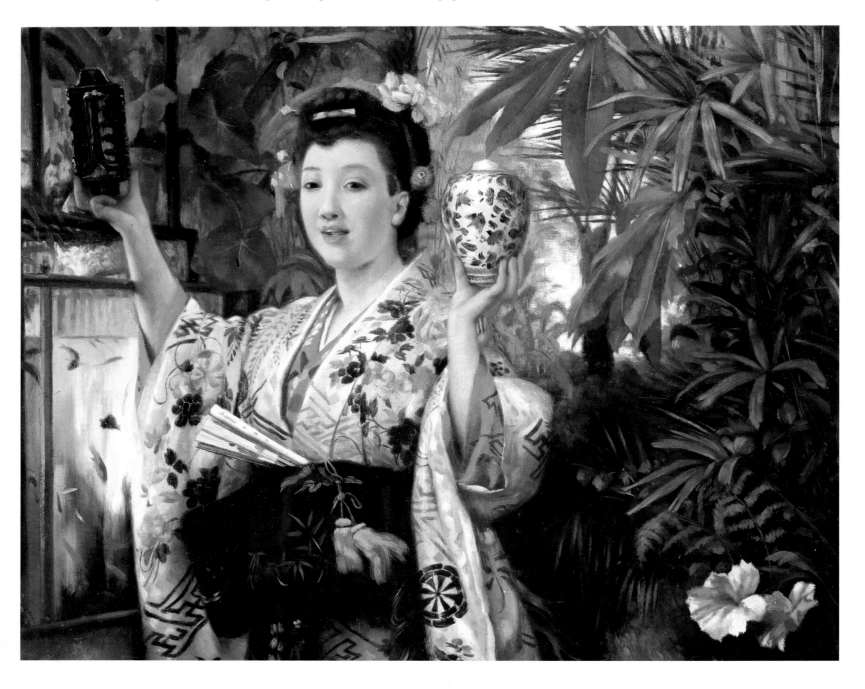

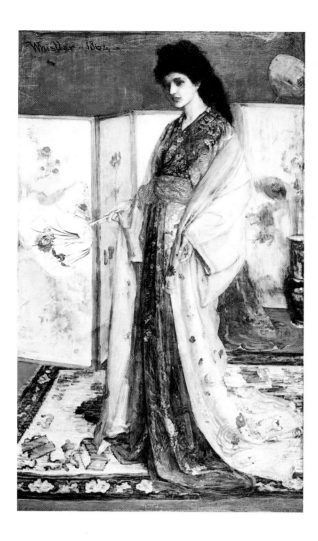

27 Whistler, *The Princess of the Land of Porcelain*, 1864.

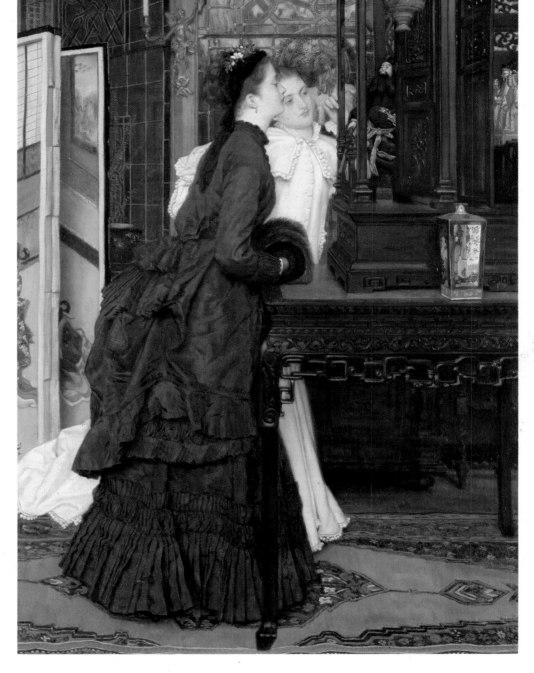

28 Young Ladies looking at Japanese Objects (*Jeunes Femmes regardant des objects japonais*), 1869.

reached its apotheosis when he was appointed *gwa-gaku*, or drawing master, to Prince Akitake, younger brother of the last Tokugawa shōgun, who led the Japanese Imperial Commission to the Exposition Universelle in 1867. Tissot's appointment lasted from March to October 1868, and several visits to his studio are recorded in the diaries of the Prince and his suite. Perhaps as a parting gift, Tissot painted a watercolour portrait of the fourteen-year-old prince, dated 27 September 1868 (29). Mounted as a hanging scroll in green and gold silk, this fascinating portrait hung in the Tokugawa collections in Japan, forgotten for over a hundred years. It was rediscovered

by a professor of Kobe University in Japan, who identified the phonetic spelling of the inscription 'chisō' as referring to Tissot.

In spite of the success both of his Japanese pictures and of other Stevens-inspired pictures of pretty girls, Tissot was continually searching for new modern-life subjects. Two unfinished sketches, *The Lunch on the Grass* and *The Terrace of the Jeu de Paume* (30), reflect this, and show an awareness of the work of Manet and Degas, but it is significant that he was not able to complete either composition. They also throw light on Tissot's working methods, which remained stubbornly traditional and academic. He always made preparatory drawings, sketches and oil studies of both individual figures and the overall composition, and gave the final picture a high degree of finish. In the 1860s, however, he began to move away from the hard, metallic surfaces of his earlier Leysian pictures, using a lighter range of colours. But his paintings of the later 1860s still have a hard surface, built up carefully with dry paint applied in small brush strokes. It was a technique that suited Tissot perfectly, and he continued to use it and develop it for the rest of his career. The experimentation with broad impressionistic effects tried by Whistler, Degas and Manet was a path which he was simply not prepared to follow, for his innate conservatism was further strengthened by a strong desire to make money and paint what the public wanted. He painted with one eye on the Salon walls, and this is why he later refused to join the Impressionist exhibitions.

One of the more ambitious modern-life pictures that he managed to finish in the 1860s was *Beating the Retreat in the Tuileries Gardens* (31). Near a monumental group of statuary in the Tuileries, a group of children and nursemaids are watching the sounding of the evening 'retreat', performed by four military drummers, three in hussar uniform, and one zouave. In the foreground a pug dog appears, the first of many in Tissot's work. The scene is set in the melancholy half-light of a November evening (this crepuscular

29 *Prince Akitake Tokugawa (1853–1910)*, 1868.

30 *The Terrace of the Jeu de Paume* (*La Terrasse du Jeu de Paume*), Paris, *c*1867.

31 *Beating the Retreat in the Tuileries Gardens* (*La Retraite dans le jardin des Tuileries*), 1867.

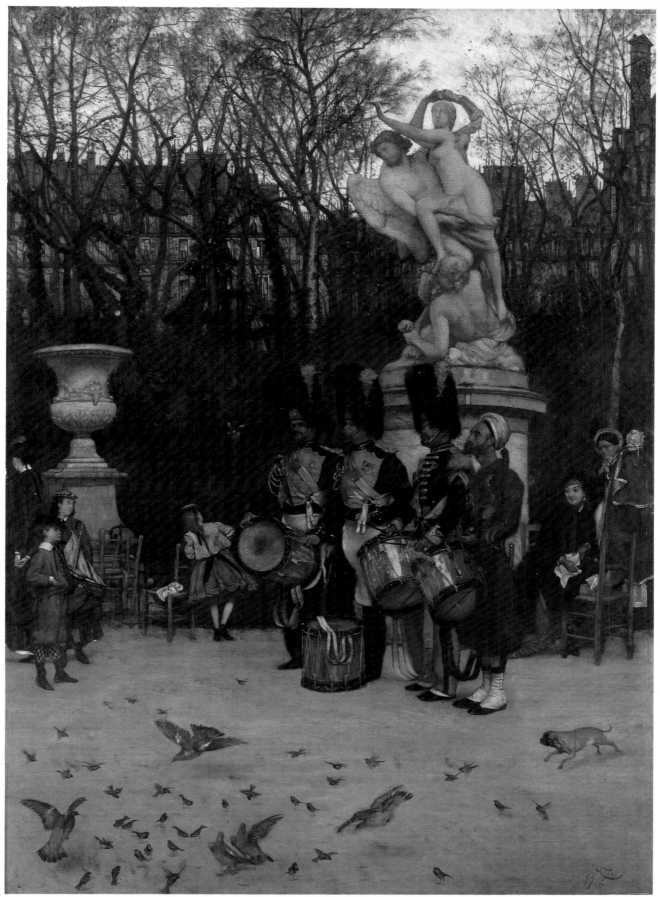

31

32 *Rêverie*, 1869.

mood was much praised by the critics), and displays both the strengths and the limitations of Tissot's style. The composition is extremely striking, and the execution and colouring are superb, but there is a tendency to hardness and a lack of aerial perspective that were to dog Tissot throughout his career. The painting reflects his absolutely literal approach to subject matter, and his commitment to a high level of technical finish.

Tissot also continued to paint Stevens-inspired pictures of fashionable ladies and Parisian life throughout the 1860s. Typical of these is *Rêverie* of 1869 (32), showing a pensive and immaculately dressed young widow sitting on an oriental couch, with the ubiquitous pug on the floor beside her, also looking thoughtful. Here Tissot is using a favourite formula, suggesting a narrative, but inviting the viewer to speculate about the situation of this young widow while deliberately leaving the story vague and incomplete. It was a formula which he was to develop and repeat with masterly effect throughout his career. Also from 1869 is *At the Rifle Range* (33) showing an Amazonian beauty of extreme elegance practising her skill with the pistol, while one of the onlookers covers her ears. Much more ambitious and humorous was *A Widow* (34) exhibited at the Salon of 1896. This pretty and obviously flirtatious young widow sits embroidering in a garden with an old lady (her mother or mother-in-law) and her daughter. Her expression is plainly bored and restive, and the direction of her thoughts is indicated by the sculpture in the background of Cupid stringing his bow. She clearly longs to return to the delights of Paris. The Parisians, in turn, were delighted with the picture, and it was a great success at the Salon. The critics complained of its 'desperate perfection' and the relentless accumulation of unnecessary detail, but this probably added to its charm for the

33 *At the Rifle Range*, 1869.

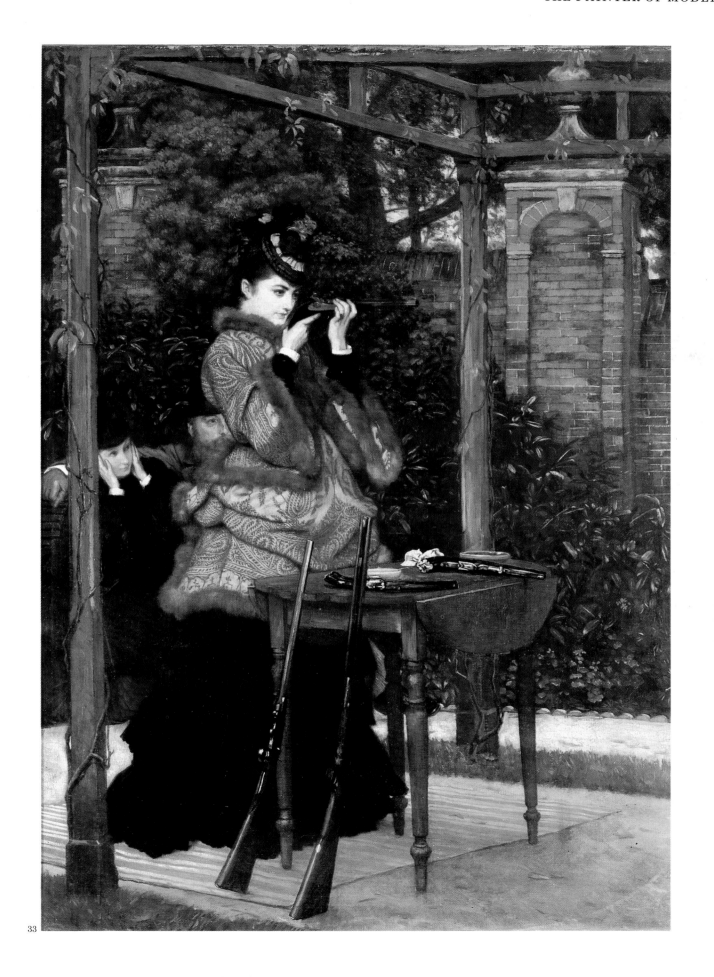

33

34 *A Widow (Une Veuve)*, 1868.

contemporary audience, and the more learned among them may also have spotted its resemblance to the story of the young widow in the fables of La Fontaine. Tissot was to return to the subject of widowhood in several later works.

Perhaps the best of this group of modern-life pictures of the 1860s, is *The Stairs* (35) also of 1869. A pretty and well-dressed girl looks through a leaded glass window into a room, clearly Tissot's own studio. She is anticipating an arrival, we know not who, and her pose and the way she grasps the books and letter in her right hand are full of suspense, immediately arresting the viewer's attention. Tissot was the master of this kind of psychological tension, of which he explored every possible nuance. All the elements in the

picture – the girl's pose, the barrier-like window, the mood of expectancy –
are combined in an extremely subtle and skilful way. This ability to lend
narrative strength to an otherwise simple subject is another quality which
sets Tissot apart from Stevens and the countless other painters of pretty
Parisiennes. Whistler's *White Girl* or Millais' *Eve of Saint Agnes* can be
cited as possible influences here, but undoubtedly Tissot has produced a
genre that is unmistakably personal and original.

During the last two years of his Paris period, from 1868 to 1870, Tissot
turned to yet another source of inspiration, the Directoire. This was an

35 *The Stairs* (*L'Escalier*), 1869.

36

37 *A Supper under the Directoire*
(*Un Souper sous le Directoire*), c1869.

38 *The Foursome (La Partie Carrée)*, c1870.

original and surprising new *appassionnement*, which may have been inspired by Edmond and Jules de Goncourt's *History of French Society during the Directoire*, published in 1855 as part of their encyclopedic studies of eighteenth-century France. They describe France under the Directoire as 'nothing but a vast place of prostitution', and it is this questionable morality and racy naughtiness that Tissot sought to convey in his pictures, most of which depict picnics, lovers' meetings, or simply saucy ladies in boats. Typical of the genre are *A Luncheon* (36) exhibited at the Salon in 1868, and *A Supper under the Directoire* (37). They are, as usual, marvels of execution. Tissot obviously took special delight in painting women's Directoire costumes: the huge hats with bows, the frilled blouses, and in particular the striped dresses are rendered with meticulous and loving precision, even if they must all have been borrowed from costumiers. But as amorous comedies they seem to the modern viewer rather coy and self-conscious, an expression of Second Empire bourgeois sensibility rather than genuine eighteenth-century *joie de vivre*.

Much the same atmosphere prevails in *The Foursome* (38), shown at the Salon of 1870, the last before the outbreak of war. It has a purely superficial resemblance to Manet's notorious *Lunch on the Grass*, which had so shocked the public seven years before, and no comparisons with it were drawn. Tissot clearly intended it as a light-hearted study of eighteenth-century manners, and as such it was an undoubted success with the public. The lady on the left looks quizzically out towards the viewer, as if inviting the spectator to join in the fun but, pretty though it is, the picture has a strained atmosphere of rather forced gaiety, quite alien to the abandon of eighteenth-century *fêtes galantes*. Overt sensuality is never very successful in Tissot's work; the more

36 *A Luncheon (Un Déjeuner)*, c1868.

subtly and indirectly he conveys it the more effective it tends to be. His single-figure studies of girls in Directoire costume, such as *Young Lady with a Fan* (39) or *On the River* (40) are as a result more effective images than those involving several figures. Perhaps best of all is the *Young Lady in a Boat* (41) of 1870, shown at the Salon with *The Foursome*. In all three pictures the same languid beauty stares boldly and impassively at the viewer, as if challenging him to disapprove. The *Young Lady in a Boat* was published as a Salon photograph entitled *A la dérive* or *Adrift*, clearly indicating that both the boat and its lovely occupant were morally off course. Pictures such as these are really a continuation of Tissot's modern-life scenes adapted to eighteenth-century costume. Stevens also regarded himself as a painter of

40 *On the River (A la Rivière)*, 1871.

39 *Young Lady with a Fan*
(*Jeune Femme à l'éventail*), c1870–1.

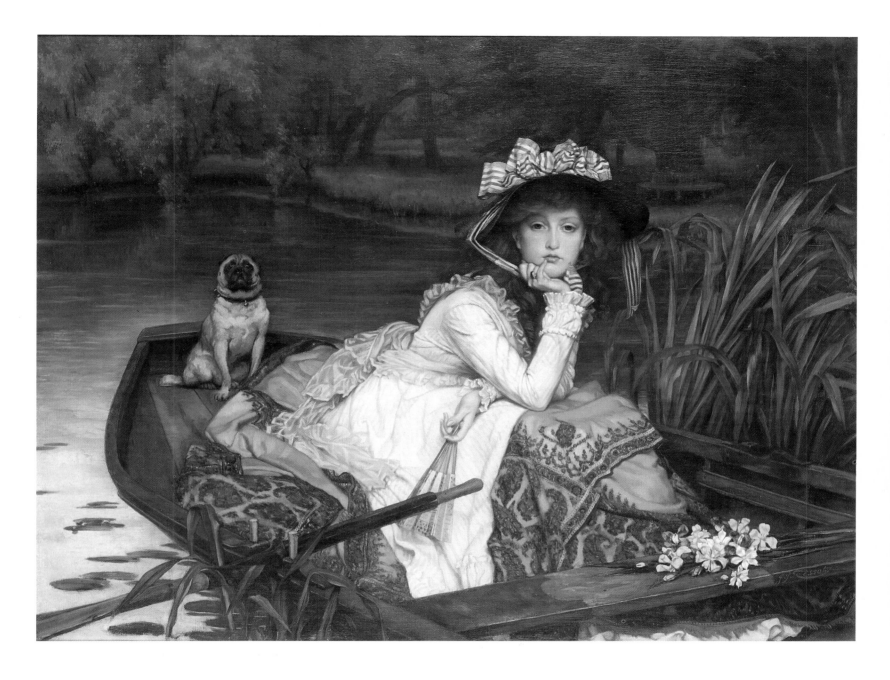

41 *Young Lady in a Boat*
(*Jeune Femme en bateau*), 1870.

nineteenth-century life in the spirit of the eighteenth-century, but to our eyes the works of Tissot, Stevens, or indeed most French nineteenth-century historical painters reveal very little about the eighteenth century and a great deal about life under the Second Empire.

1870 was a turning point both in French history and in the career of James Tissot. On 15 July 1870, France was goaded by Bismarck into a reluctant declaration of war against Prussia. After a campaign lasting less than two months, the Emperor Napoleon III surrendered at Sedan with 80,000 men in one of the most humiliating disasters in French military history. The Emperor and his wife Eugénie fled to England; and in Paris a Republic was proclaimed amid general rejoicing. Any joy the Parisians may have felt at the fall of the Empire was quickly dispelled, however, as the Prussian army advanced on Paris, laying siege to it by 19 September. The rest of Europe looked on with barely concealed satisfaction: in their eyes, Napoleon III was

a dangerous adventurer who had met with his just deserts, and now they looked forward to the fall of the great modern Babylon, Paris. But contempt turned to admiration as the starving city resisted bravely through the worst winter of the century.

Tissot took an active part in the improvised defences of the capital. He joined two companies of the Garde Nationale, first the Eclaireurs de la Seine, and later the Tirailleurs de la Seine. Along with several fellow-artists he saw a certain amount of active service during the winter of 1870–1, until the final capitulation of Paris on 28 January 1871. He recorded his experiences in a small number of drawings and watercolours and only one oil, of a bombed house, which were later used as a basis for prints and illustrations (43). Seven in particular were engraved on wood in London in

42 *A Girl in an Armchair* (*The Convalescent*), 1870.

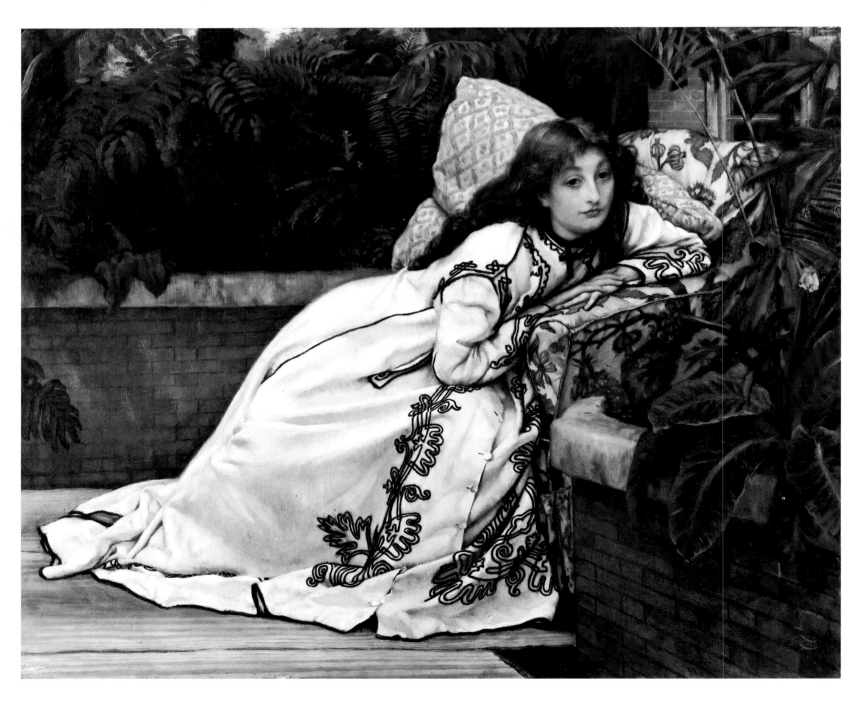

1871 to illustrate *The Defence of Paris* by Thomas Gibson Bowles, the editor of *Vanity Fair*, whom Tissot first met in 1869. Their friendship was to prove extremely valuable to Tissot during this difficult stage of his career: at first Bowles commissioned him to do a few caricature drawings for *Vanity Fair*, and then, during the siege, they met again by chance when Bowles visited Paris as special correspondent for the *Morning Post*.

After the capitulation of Paris came one of the most questionable and mysterious episodes in Tissot's career – his supposed involvement with the Commune, the violent popular revolution that followed the departure of the Germans. The Communards threatened to confiscate the possessions of the rich and burn their houses, and Tissot was alleged to have joined the Commune in order to protect his own house and its precious belongings. This surprising but persistent rumour has dogged Tissot's reputation ever since, and is repeated by many writers. Jacques-Emile Blanche, for instance, in his notoriously inaccurate memoirs, *Portraits of a Lifetime*, quotes his own father saying of Tissot, 'May God forgive him his cowardice!' When the Versailles government finally recaptured Paris and put down the Commune with extreme violence, Tissot fled the city, and it was this act, above all, that aroused suspicions of his involvement with the Commune. The strain of living in Paris through such a turbulent period, with mobs burning and looting, and Government troops massacring 20,000 Communards in the streets, may well have pushed Tissot into some hasty or ill-considered decision. Other sources claim that Tissot joined the Commune for patriotic reasons, to express his disappointment with the French government, and yet others that it was a simple case of mistaken identity, and that the charges referred to another Tissot, called Antoine. The true answer to the mystery will probably never be known. What is certain is that by 1874 Tissot was free to return to Paris, and had no need to wait until the general amnesty of 1880. In a letter to Tissot written in about 1874 Degas refers to 'official news' relating to Tissot's return, obviously implying that his name had been removed from the lists of the proscribed. So his offence may have been trivial or may not even have existed at all, but the odium of it lingered for the rest of his career, persisting to the present day.

Even if the reasons for Tissot's departure from Paris were partly political, his choice of London was obviously a practical one for an artist. Paris was in chaos; the art market ruined. London he already knew, he had friends and fellow artists there to help him start a new career, and it was a thriving artistic capital which rewarded its successful artists handsomely. In about June 1871 Tissot arrived with only a hundred francs in his pocket; during his eleven-year stay in England he is said to have earned over a million francs.

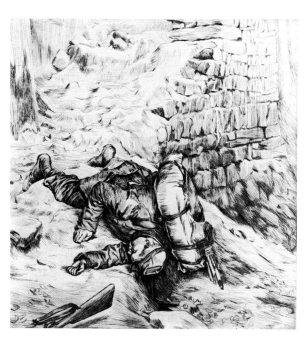

43 *The First Man that I saw killed* (*Souvenir of the Siege of Paris*), 1876.

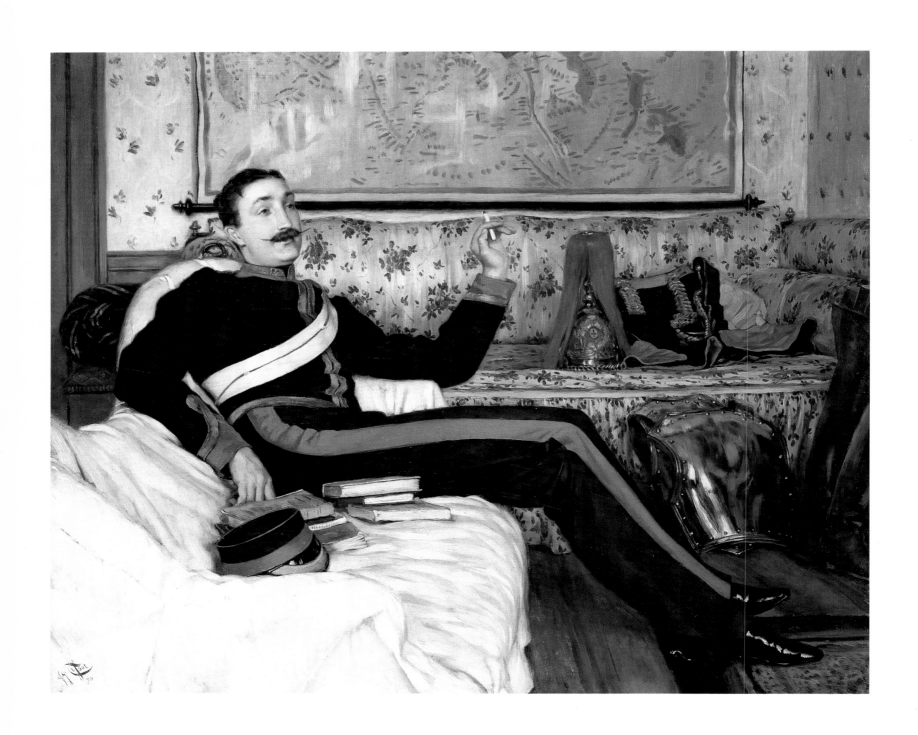

LONDON
1871-1876

The Painter of Vulgar Society

Tissot arrived in London shortly after the fall of the Commune, probably in June 1871. After the trauma of his hasty departure from Paris, still in the grip of revolutionary strife, it must have been a relief to him to find a safe haven at the house of his friend Thomas Gibson Bowles. Bowles not only gave him shelter for several months at Cleeve Lodge, Hyde Park Gate, until he was able to find a house of his own, but also gave him a job producing cartoon portraits for his magazine *Vanity Fair*.

44
Colonel Frederick Gustavus Burnaby, 1870.

Tissot had already contributed sixteen drawings to *Vanity Fair*, mostly of European monarchs and leading political figures, some with a highly satirical and critical flavour. Typical of these are his drawings of Napoleon III (46) and the Sultan of Turkey (47). After his arrival in London, however, his style of caricature changed markedly to a milder, more easy-going approach, reflecting the influence of the two other famous caricaturists on *Vanity Fair*, Carlo Pellegrini ('Ape'), and Leslie Ward ('Spy'). Their style was gently witty rather than malicious, and Tissot, with his usual skill,

46 *Napoleon III.*

45 *A Dandy.*

47 *Abdul Aziz, Sultan of Turkey, c1869.*

quickly adapted himself to it. Between 1871 and 1873 thirty-nine more of his caricatures were published, followed by another eleven in 1876 and 1877. Some, while not particularly original, have considerable style and wit, such as George Whyte-Melville the novelist (48) looking elegant and worldly, Frederic Leighton languishing gracefully in a doorway (49), or the portrait of an unknown dandy (45). His caricatures form an interesting sideline in Tissot's work, though not one he wanted to pursue when his career as a painter began to prosper, but they performed a vital function in providing

48 *George Whyte-Melville, The Novelist of Society.*

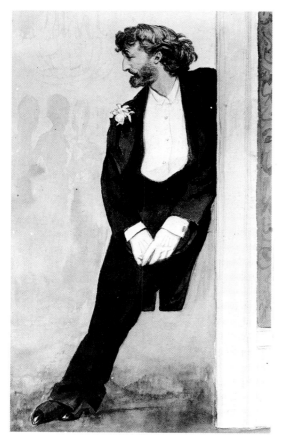

49 *Frederic, Lord Leighton,* 1872.

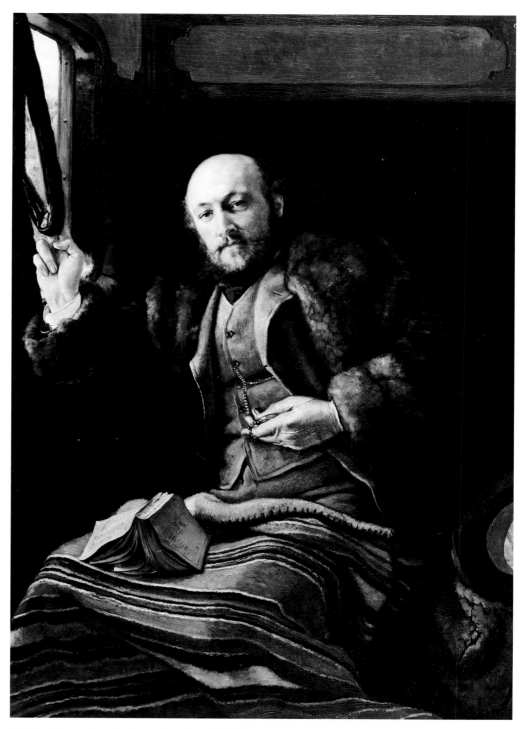

50 *Gentleman in a Railway Carriage (M.le Capitaine* * * *), c*1872.

him with a much-needed income during his early years in London. They also helped to establish his name and reputation in England, although they had unforeseen consequences when later some English critics accused him of trying to satirize English society in his pictures of society life.

The caricatures may also have helped to establish Tissot as a painter of male portraits, two of which he exhibited at the London International Exhibition of 1872: the celebrated *Colonel Frederick Gustavus Burnaby* (44) and *Gentleman in a Railway Carriage* (50). The first, dated 1870, had been commissioned about a year earlier by Bowles. Colonel Burnaby (1842–85) was a dashingly successful cavalry officer and adventurer, whose extremely colourful career was brought to an end during the attempt to relieve Khartoum in 1885. The hero of Ouida's novel *Under Two Flags* bears a striking, though possibly coincidental, resemblance to him, and he was the type of military hero to be found in many books and magazines of the period, be they Ouida, Henty or the *Boy's Own*. He was also a friend and partner of Bowles who had helped him to found *Vanity Fair* in 1868, contributed articles to the magazine, and wrote books about his adventures.

Tissot's painting of him is one of the best of all his portraits, and can also claim to be a minor masterpiece of Victorian portraiture. The combination of strength and elegance is superbly suggested by the soldier's languid pose, leaning back on the sofa, a cigarette in his left hand. Surrounded by books and military accoutrements, with a map of the world behind him, he seems to have been caught in the middle of recounting the story of one of his own adventures. The dark colours of his uniform stand out brilliantly against the paler tones of the background, and Tissot has made excellent use of the touches of red, especially in the long stripe down Burnaby's leg, which emphasizes his height and his relaxed elegance in a particularly effective way. This is surely the most elegant pair of legs in Victorian art.

Gentleman in a Railway Carriage (50) was exhibited under the title *Portrait of Captain* * * *, and has never been identified more precisely. Here is another elegant figure, in a fur coat, with a travelling rug and book on his knees, looking at his watch and holding on to a strap, which brilliantly suggests the movement of the train. In placing his subject in so modern and everyday a setting as a railway carriage, Tissot was already showing a considerable appreciation of Victorian narrative painting. Abraham Solomon's pair of railway pictures, *First Class* and *Second Class*, had been painted as early as 1854, but were still widely known through engravings. Frith's *Railway Station*, the best-known of all Victorian railway pictures, had also appeared long before, in 1862. Tissot made his own contribution to the genre, subtly combining a portrait with the traditions of Victorian narrative painting, but bringing to the result a French panache which no Victorian artist could match. Here we see the first signs of Tissot beginning to adapt his style to suit the English market.

The third and last of Tissot's English male portraits was that of *Chichester Fortescue*, later first Lord Carlingford (51), painted in 1871. Larger in scale than the other two, its size reflects the official nature of the commission. The portrait was commissioned for his wife by an illustrious group of peers, MPs and Roman Catholic bishops to commemorate his term as Chief Secretary for Ireland. The result was a handsome and stylish but not particularly penetrating portrait stylistically similar to his French portraits

51 *Chichester Fortescue, first Lord Carlingford*, 1871.

of the 1860s, such as *Eugène Coppens de Fontenay*. It certainly indicates how quickly, with the help of *Vanity Fair* and Bowles' invaluable connections, Tissot was able to establish himself as a fashionable artistic figure in England.

By the following year Tissot was ready to send his first English pictures to the Royal Academy, *The Farewell*, or *Les Adieux* (52), and *An Interesting*

52 *The Farewell* (*Les Adieux*), 1871.

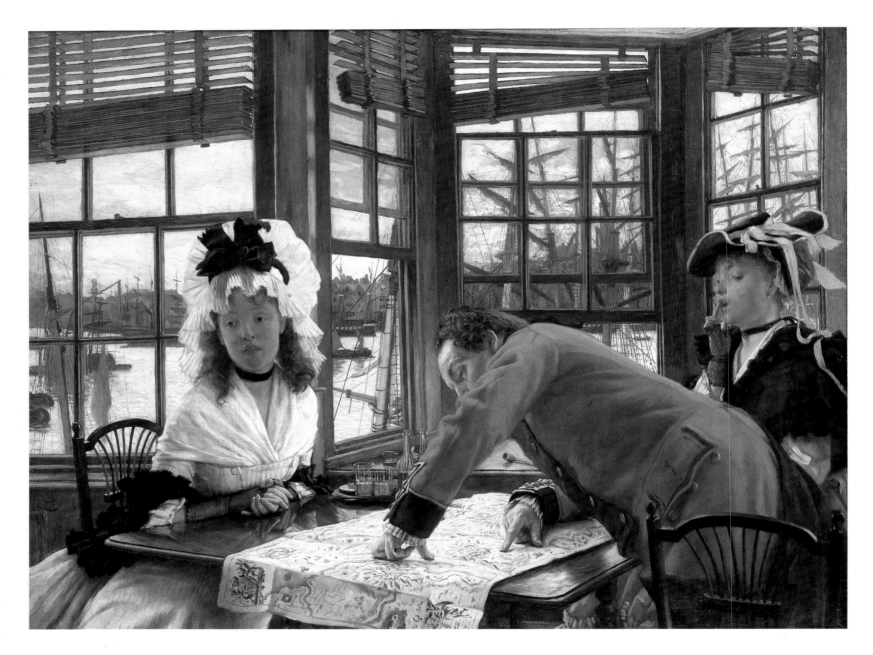

53 *An Interesting Story*, c1872.

Story (53), both of which proved extremely popular. For his first important test of the British public Tissot played it safe and set both pictures in historical costume. In *The Farewell*, a pair of eighteenth-century lovers stand holding hands through the metal railings of a gateway, while the man's horse stands waiting. The two figures are particularly successful, and the picture was praised for its 'sentiment without sentimentality': the emotion is restrained, and yet the atmosphere is full of tension and genuine distress. It was very much to the English taste, and Tissot could have had many prototypes in mind, in particular Millais' famous *Huguenot* of 1853, which had unleashed a vogue for endless pictures of unhappy lovers by garden walls. The English public was familiar with the type, even too familiar, but Tissot very cleverly produced something slightly different; a French variation on an English theme, and popular enough to be produced as a steel engraving.

An Interesting Story (53) was yet more popular. Those who found *The Farewell* too obscure, lacking any specific literary or historical reference,

could clearly understand this little comedy of manners. Set once again in late eighteenth-century dress, the scene shows a red-coated officer poring over a map and relating a story to two pretty girls, who are finding it difficult to disguise their boredom. Here Tissot has cleverly transformed the rather saucy Directoire scenes of his Paris period into something much more English. In spite of the Pre-Raphaelite vogue of the 1850s, and the other developing currents of the 1860s, the English still had an almost limitless appetite for historical and literary scenes, especially if both eighteenth-century and humorous. It was a taste specifically catered for by Frith in particular, but also countless others such as John Callott Horsley, William Maw Egley, Daniel Maclise and Alfred Elmore. Later it was to find new expression in the work of the so-called St John's Wood Clique, such as George Dunlop Leslie and William Frederick Yeames, painter of the famous *And When did You Last See Your Father?*

Encouraged by the success of *An Interesting Story*, which the *Athenaeum*

54 *Bad News* (*The Parting*), 1872.

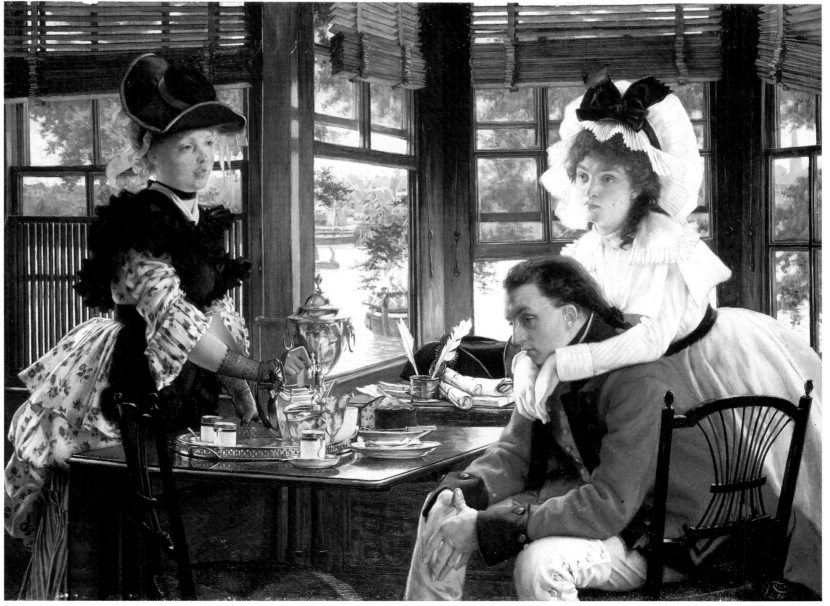

critic described as 'a capital piece of humorous characterisation', Tissot produced several variations on the same theme. *Bad News* (*The Parting*) (54) shows an officer about to take his leave of two very pretty girls, one of whom prepares a tea-tray. *Tea-Time* (*Le Thé*) (56) shows the same girl again preparing the tea, only this time overlooking the river Thames rather than a garden. *The Tedious Story* (55) or *Histoire ennuyeuse* is a variation on the left-hand girl in *An Interesting Story*.

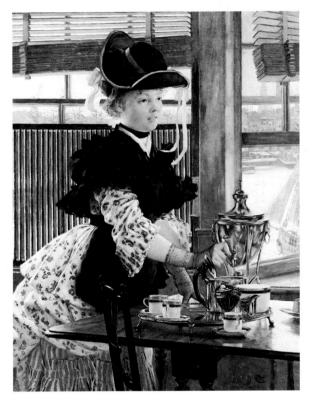

56 *Tea Time* (*Le Thé*), 1872.

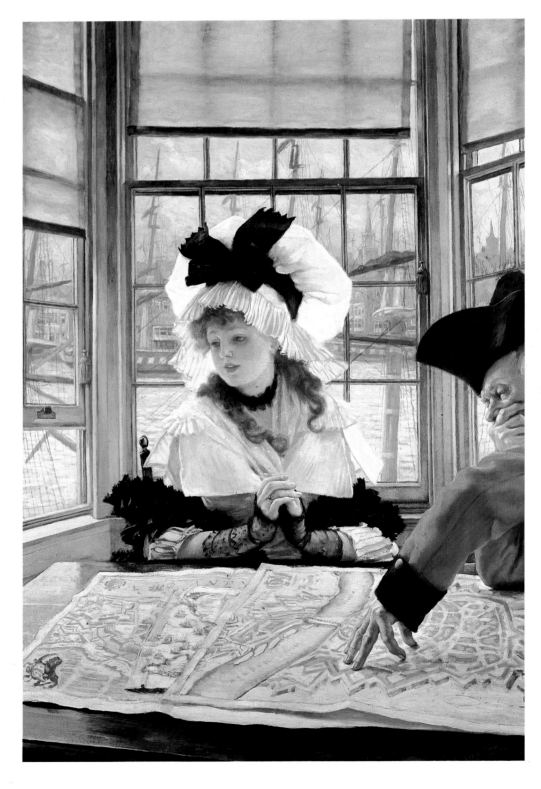

55 *The Tedious Story*, c1872.

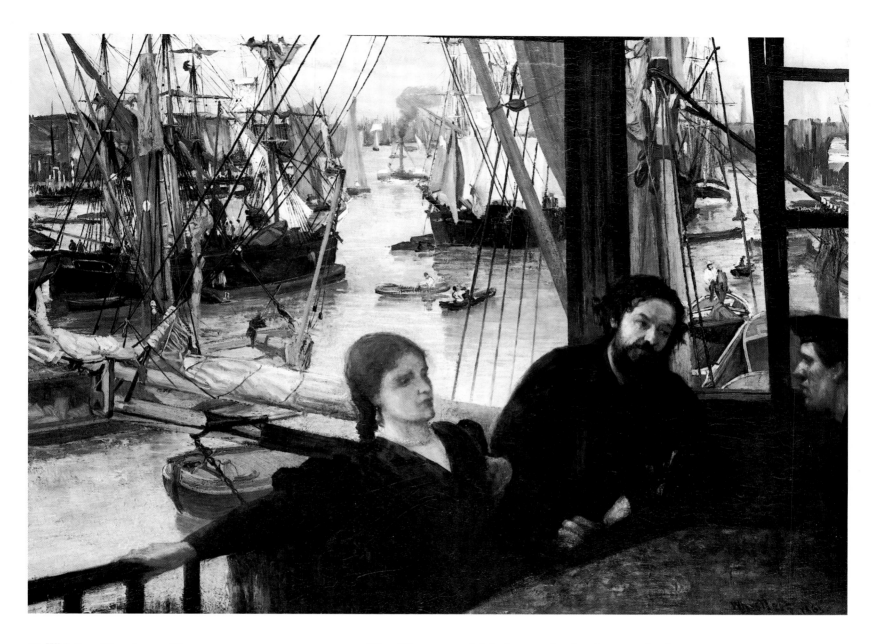

57 Whistler, *Wapping on Thames.*

The Thames, which forms the background of two of these pictures, was itself to become a new *appassionnement* for Tissot. In this he may have been influenced by renewed acquaintance with his old friend Whistler, now living in London, who had already been painting scenes on the river for several years (he exhibited *Wapping* (57) at the Exposition Universelle of 1867) and produced his *Thames Set* of etchings in 1871. Quite apart from its artistic appeal, he must have found the Thames a place of endless fascination, reminding him of his boyhood days in Nantes. Londoners may have taken the river for granted, but Tissot recognized the extraordinary visual possibilities of the docks, warehouses and wharves of the Pool of London, at the time one of the greatest and busiest ports in the world. Remarkably few English artists thought it worth painting; William Lionel Wyllie's *Toil, Glitter, Grime and Wealth* is one of the few attempts to catch its spirit. It was this commercial area from Tower Bridge to Greenwich which Tissot found most inspiring, and which was to provide the setting for many of his most memorable pictures of London.

58 *The Captain's Daughter*, 1873.

At the Academy of 1873 Tissot exhibited two of these riverside scenes, *The Captain's Daughter* (58) and *The Last Evening* (60). Doubtless emboldened by the success of his pictures at the Academy of 1872, he turned to modern dress for both pictures. In the first, *The Captain's Daughter*, the Captain sits discussing his daugher with her sailor suitor, while the girl herself stares dreamily and rather listlessly out over the river, like Bella Wilfer in Dickens' *Our Mutual Friend*. The setting is a deliberately plain and unpretentious jetty by the Thames, as if to emphasize the plebeian nature of this little romance, and the sailor conforms to the conventional Victorian image of a hopelessly amorous swain. But Tissot brings to the scene his own very subtle and sophisticated style, and the painting was another great success at the Academy, popular with the public and critics alike. Infinitely more complex and sophisticated is the remarkable *Last Evening*, now probably one of Tissot's best-known London pictures. In the foreground sit the unhappy couple about to part, she in a bentwood rocking-chair, he behind her in a wicker chair. The woman, wearing a checked jacket and with a tartan rug on her knees, is one of Tissot's most remarkable

59 Study for *The Last Evening*, c1873.

60 *The Last Evening*, 1873.

figures, for which he made a study in watercolour and pencil (59). The intensity of the man's gaze, and his hand on the back of her chair, seem symbolically to bind the two figures together, creating an extraordinary atmosphere of tension and impending unhappiness. Meanwhile two rather grim-looking men on the bench in the background are obviously discussing the unhappy pair, who seem totally absorbed in themselves and oblivious of anything else. The little girl seems to have been introduced to lighten the narrative and to encourage speculation as to whose daughter she might be. Behind them is a fantastic web of ships' rigging and masts, painted with all the minute brilliance of which Tissot was capable. The picture is a *tour-de-force*, combining Tissot's French brilliance and the more pedestrian traditions of Victorian narrative painting in a unique mixture.

Tissot painted several other shipboard scenes in 1873, which was a highly creative and productive year for him. The cast of *The Last Evening* (in real life a ship's captain named John Freebody and his family) were reassembled for the even more elaborate *The Captain and the Mate* (61). Against an even

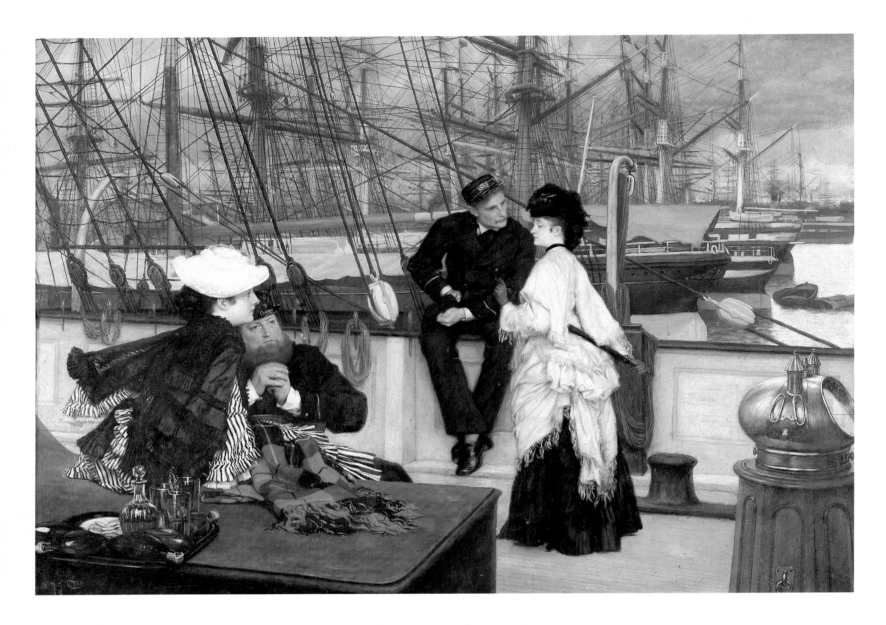

61 *The Captain and the Mate*, 1873.

more breathtaking background of ships' rigging, the two couples parade mysteriously before us, giving practically no clues to the viewer. But if the narrative is impenetrable, the mood is not: the grey, overcast sky and the black network of ropes create a sombre atmosphere of foreboding.

The general tone of all these shipboard scenes, however, is considerably brigher than Tissot's earlier work. Clearly he had deliberately raised the pitch of his colours higher to suit the prevailing English love of bright colour. To do this he used a great deal of white, which gave a chalky appearance much commented on by the critics, who thought they perceived Whistler's influence and called the paintings more 'Symphonies in White'. Whistler had been dubbed 'the Claude of Old Chelsea', and it was not long before the *Daily Telegraph* was calling Tissot 'the Watteau of Wapping'.

From the same year is *Boarding the Yacht* (62), a shipboard romance using the same models, but with a touch of humour. The stout and bewhiskered Captain's dilemma as he hands two pretty ladies aboard his yacht – which to choose? – was a subject which fascinated many Victorian artists (notably John Callcott Horsley, who painted *Showing a Preference* in

62 *Boarding the Yacht*, 1873.

62

1860). During the 1870s Tissot frequently dramatized this theme which, although popular with the public, tended to shock the more fastidious critics. Another burning topic in England was emigration, which inspired such pictures as *The Last of England* by Ford Madox Brown, and *The Emigrant's Last Sight of Home* by Richard Redgrave. Tissot turned to the subject in *The Emigrants* (63) of 1873, now a lost picture, but known through a smaller replica.

Tissot was to continue painting shipboard pictures and scenes by the Thames for the rest of his English period. But this was not the only avenue by which he explored that phenomenon so fascinating and mysterious to foreigners: English social life. His third exhibit at the Royal Academy in 1873 depicted life in the English ballroom, and the result was the picture some consider his masterpiece, *Too Early* (64). A party of three ladies and an elderly gentleman have arrived too early for a ball; they stand in the middle of the room, the man clearly in a state of Pooterish social embarrassment, while to the left the hostess gives last minute instructions to the band. Nearby, two giggling maids peer through a doorway, doubtless adding to the embarrassment of the arrivals. In another doorway to the right stand a completely relaxed couple, who by contrast seem curiously detached from the proceedings and quite unembarrassed, the man's pose recalling Tissot's caricature of the young Frederic Leighton drooping in a doorway. The picture was an immediate and deserved success. Louise Jopling, also an artist and a friend of Tissot, recalled in her memoirs in 1925 what 'a great sensation' was made by *Too Early*, 'a new departure in art, this witty representation of modern life'. The critics agreed, and so did a wealthy collector, Charles Gassiot, who acquired the picture through Agnew's, before it was exhibited at the Academy, for 1050 guineas.

It was indeed a remarkable picture for a young Frenchman to have painted, so soon after his arrival in England, poor and virtually unknown. But while to many it seemed a new and witty departure in English art, in reality Tissot drew his inspiration from illustrated magazines such as the *Graphic* and the *Illustrated London News*, which employed a great many artists as illustrators. In the *Illustrated London News* of 1872, for example, Frederick Barnard illustrated a scene entitled *The First to Come*, which was clearly a precursor of *Too Early*, showing a nervous young man launched into a drawing room by a superior butler. Court and social events were regularly illustrated in these magazines, but no painter had hitherto thought them worthy of painting, and it was part of Tissot's genius to see in them a potential subject. The result was an extraordinary combination of French style and English narrative, highlighted by Tissot's very personal technique, which was able to portray every detail of the ladies' dresses in brilliant detail, and bathe the whole scene in a bright, shimmering light. It was a great achievement, much more popular than his other large-scale social scenes, such as *Hush!* or *The Ball on Shipboard*, and has deservedly remained one of the most acclaimed of all Tissot's pictures.

The following year *The Ball on Shipboard* (65) was exhibited at the Royal Academy. Although unquestionably the most brilliant of all Tissot's English pictures, it met with a surprisingly hostile reception. It was accused of lacking a coherent narrative, of being too harsh and garish in colour, and, worst of all, of being simply vulgar. The *Athenaeum* critic could find 'no

63 *The Emigrants* (small version), 1873.

pretty women, but a set of showy rather than elegant costumes, some few graceful, but more ungraceful attitudes, and not a lady in a score of female figures', an extraordinarily supercilious judgement which seems virtually incomprehensible to the twentieth-century viewer, who probably regards

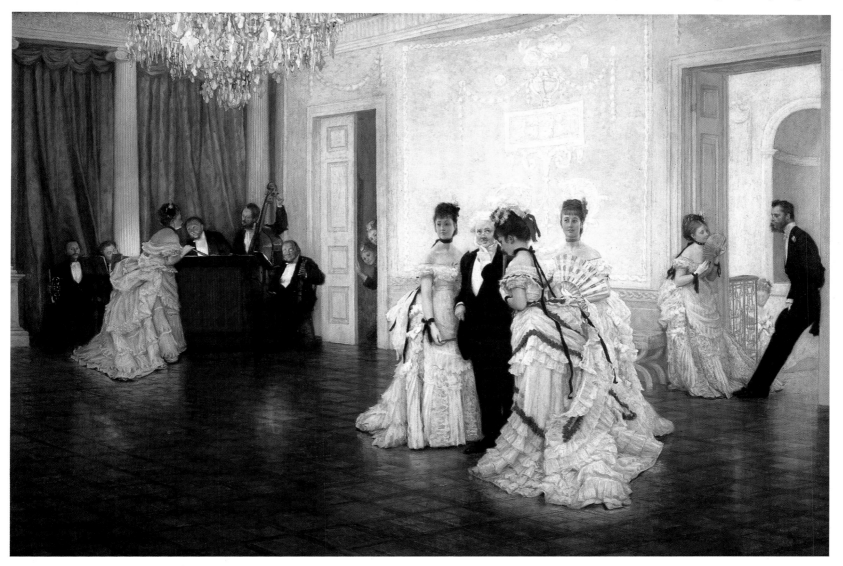

64 *Too Early*, 1873.

The Ball on Shipboard as the essence of Victorian chic and elegance. Sacheverell Sitwell in his book *Narrative Pictures*, published in 1937, even suggested that it depicted a dance on board the Royal Yacht at Cowes during the visit of the Tsar in 1873. Present-day viewers tend to assume that *The Ball on Shipboard* records the life of the Victorian upper classes, but contemporary criticisms underline forcibly the fact that Tissot's world was far from aristocratic. To the average English critic of the 1870s Tissot's pictures clearly represented the rather flashy world of social-climbing nouveaux-riches; they were therefore held in some distaste, and dismissed by Ruskin for instance, as 'mere coloured photographs of vulgar society'. This dichotomy between our view of Tissot and that of his contemporaries is one of the most difficult gulfs for the historian to bridge. Where we love Tissot for his elegance and style, the Victorians saw only the coarse and

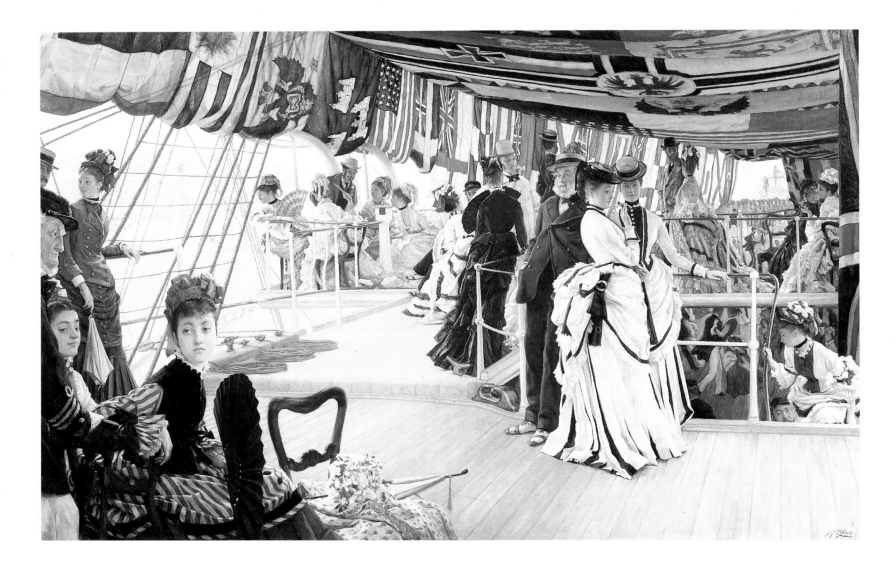

65 *The Ball on Shipboard*, c1874.

absurd spectacle of the aspiring middle classes trying to emulate their social superiors. It was this taint of vulgarity that was eventually to lead to Tissot's failure with the English public in general, and the Royal Academy in particular.

Leaving aside its chequered critical history, we can now appreciate *The Ball on Shipboard* for what it is – one of the most dazzlingly festive and colourful pictures of English life ever painted. Tissot undoubtedly painted most of it in his studio, using his own collection of dresses, flags and other props, and he composed it with seemingly effortless brilliance. Not only are the poses of the figures elegant and chic, especially the ladies, but they are also superbly placed on the canvas. The group of figures to the left, placed close to the viewer and with one figure abruptly cut off, leads the eye into the picture, and enhances the atmosphere of naturalness and informality. The other main focal point is the group of two ladies in identical dresses and the bearded gentleman by the rails at the top of the stairway. Tissot has cleverly used a wide expanse of deck to isolate the groups from each other and increase the dramatic effect: he was a master of the very theatrical art of leaving space between his figures, a device also brilliantly exploited by the Scottish painter William Quiller Orchardson in such pictures as *The First*

Cloud and *Mariage de Convenance*. In narrative pictures space can be as eloquent as gesture, and no one exploited the space between his figures as well as Tissot. He also loved flags, and nowhere do they appear in such profusion as in *The Ball on Shipboard*, covering the whole of the deck with a dazzling canopy of colours, stripes, and patterns. They greatly enhance the festive atmosphere, countering the rather static and expressionless poses of some of the figures. Although it is a ball, the guests are not visibly enjoying themselves, and dancing couples can only be glimpsed in the background. The spectator, however, can enjoy what is one of Tissot's most brilliant and complex designs, and undoubtedly one of his English masterpieces.

Even more unpopular at the Royal Academy was Tissot's other picture of 1874, *London Visitors* (66). This is also one of his undoubted masterpieces, and now one of his best-loved works, but the critics could not find a good word to say for it, attacking it for lack of meaning and accusing the colouring of being arctic and the figures uninteresting. It seems to us well nigh inexplicable that Tissot's contemporaries could not see the virtues of this extraordinary picture, which is one of his finest and most striking works. The composition, looking up the steps of the National Gallery with St Martin-in-the-Fields in the background, is extremely effective, placing the figures well above eye level. The picture is unusually large for Tissot, but its size in no way diminished its quality. The predominantly grey and muted tones are evocative of London on a dull and wintry day: the smoky atmosphere of the city fascinated Tissot, and this is undoubtedly one of the best of his renderings of it.

At the Academy of 1875 Tissot exhibited the third of his major social pictures, *Hush!* (67), a glittering drawing-room scene showing guests assembling to hear a concert. He was clearly trying to counter the barrage of criticism that had met *The Ball on Shipboard* and *London Visitors* the year before by repeating the success of *Too Early*, and by and large he succeeded. There were no criticisms of lack of meaning or glacial colouring this time, and London society amused itself by trying to identify the figures. There are many legends about who the people in the picture actually are, but they were probably based on a party Tissot attended at the house of a family called Coope, where the violinist Madame Neruda performed. Beyond this no identification of the figures is possible, except for two painter friends of Tissot, Giuseppe de Nittis and Ferdinand Heilbuth, who are among the figures in the doorway. The rest of the gathering are probably models or generalized types, and even the violinist does not resemble Madame Neruda. None the less, they were assumed to be portraits, and several critics even complained of the strong element of caricature in the picture. The critic of the *Illustrated London News*, for example, wrote of 'a Gallic sneer' running through the picture, suggesting that the *Vanity Fair* cartoonist was secretly lampooning English society. There is indeed an element of caricature in the figures that is still apparent to the twentieth-century viewer. This was due not to any satirical intent on Tissot's part, but simply to his French viewpoint. As a foreigner he naturally saw the idiosyncratic aspects of English life which would be either invisible or unremarkable to English people. The same critic was closer to the mark when he went on, 'But polite people will, of course, be thankful to see themselves as a polished Frenchman sees them.' Tissot was the perfect society painter because he

66

67 *Hush!* (*The Concert*), c1875.

66 *London Visitors, c1874.*

painted society as it wished to see itself – elegant, glamorous and self-satisfied.

Hush! enjoyed almost as great a success as *Too Early*, and was bought, again by Agnew's, for 1200 guineas. Although not as witty or as charming as *Too Early, Hush!* is certainly one of Tissot's English masterpieces. The handling of the complex groups of figures to the left, in the doorway and up the stairs is especially successful. In particular, the elegant lady with the fan who sits with her back to the spectator is a marvel of chic and elegance. Only Tissot could make a lady's back the most graceful thing in the room. The colouring of the picture marks a distinct development in his technique: he was now beginning to move away from the hard, glossy finish of the 1860s and early 70s towards a more fluid, painterly style. His colours become warmer, his handling looser, and under close inspection the surface of his pictures breaks up into small touches of colour instead of the smooth, impenetrable gloss of his earlier works. Tissot was at long last becoming an Impressionist.

The years 1871–5 were an extraordinarily creative and productive period in Tissot's career. He obviously found the stimulus of the English market a challenge, and responded to it with a succession of masterpieces. Apart from

the major social scenes such as *Too Early* and *Hush!*, he also produced a number of paintings exploring and developing new themes and ideas. The Thames continued to be the main source of inspiration, and Tissot looked up-river to Maidenhead and Henley for the settings of a number of pictures, usually involving stylish women and boats.

On the Thames, a Heron (69) and *Autumn on the Thames (Nuneham Courtney)* (68) both date from *c*1871–2, and show the continuing influence of Japanese art on Tissot's style. *Autumn on the Thames*, in particular, with its

69 *On the Thames, a Heron, c*1871–2.

68 *Autumn on the Thames,*
*(Nuneham Courtney), c*1871–2.

70 *The Return from the Boating Trip*, 1873.

high viewpoint and billowing dresses clearly recalls Harunobo's print *A Windy Day by the River* (c1768). Unlike some of his earlier attempts at a Japanese style, this elegant picture shows Tissot successfully combining Japanese elements with his own style and subject matter. It is also a good example of his use of the seasons to suggest a mood: autumnal browns and yellows predominate, giving the picture a sombre atmosphere. *The Return from the Boating Trip* (70) explores the same theme, apparently with two of the same models.

Conservatories, which reached the apotheosis of their splendour in the

71 *On the Thames, c*1882.

late Victorian period, provided Tissot with the perfect exotic setting for some of his choice specimens of female elegance. *A Girl in an Armchair* (42) has a background of ferns and other conservatory plants; and *The Bunch of Lilacs* (1) carries the theme much further, the entire background being filled with huge palms and tropical plants. Set in the conservatory of Tissot's own house in Grove End Road, St John's Wood, this is one of his most successful pictures in the keepsake manner of Alfred Stevens, combining delicate colours, shimmering surfaces and an exotic setting in a wonderfully striking ensemble.

Similar in scale is *Reading the News* (72), which rather surprisingly

72 *Reading the News, c*1874.

72

juxtaposes a superbly chic young lady in white at the tea-table with a Chelsea Pensioner reading a newspaper. The combination is typical of Tissot and underlines the difference between his outlook and that of English painters, who would never have thought of placing two such socially incompatible figures together. Tissot, however, simply found the Pensioner's uniform picturesque. A Victorian artist would have used the Pensioner in quite a different way, as for instance in Herkomer's emotive painting set in the chapel of the Chelsea Hospital, *The Last Muster* (1875).

Tissot was also quick to adapt the potent and popular themes of sickness and convalescence to his own use, and produced several pictures of gracefully ailing females during the 1870s. One of the first, *A Convalescent* (73) is set in his own garden, which he was to use in several other pictures. He installed the colonnade around the pool himself, and was evidently proud of it, as it often makes an appearance in both his pictures and his etchings. In

73 *A Convalescent*, c1876.

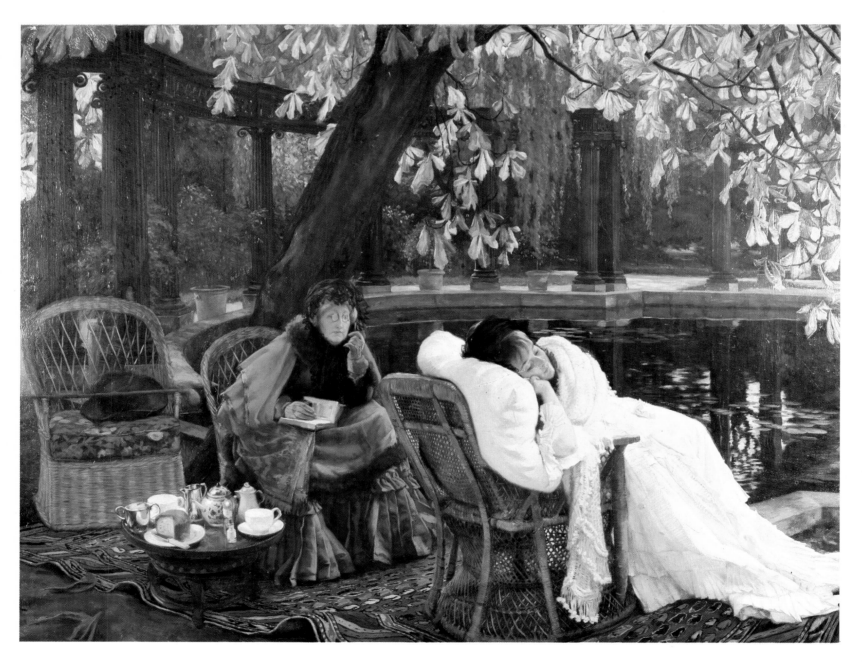

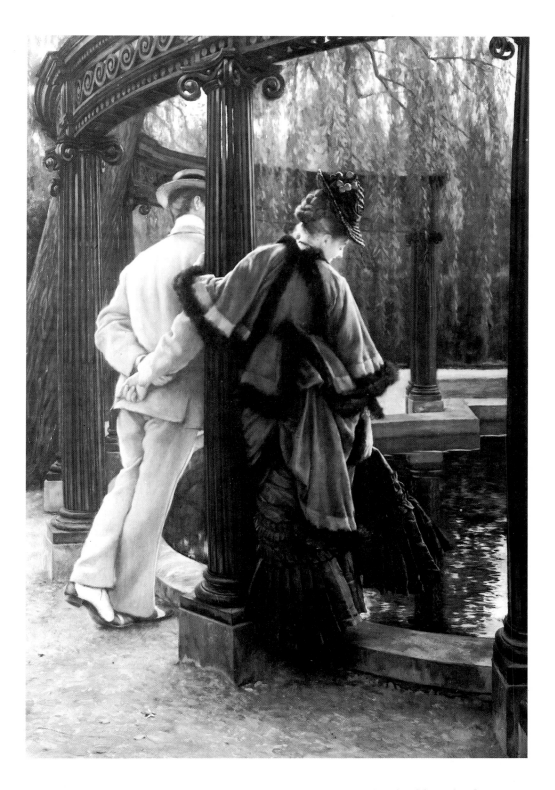

74 *Quarrelling (Querelle d'amoureux)*, 1876.

Quarrelling (74) it plays an active role, providing a physical barrier between the two lovers having a tiff by the pool. The course of true love and its failure to run smooth was as fruitful a theme as convalescence for Victorian artists, and Tissot brought his own unmistakable elegance to both themes. How very different his *Convalescent* is from most Victorian attempts at the subject, which usually involve mothers anxiously watching over sick children, or moist-eyed maidens offering up prayers. Tissot's convalescents never give the impression of being seriously ill, but they know how to be ill

in style. And his *Quarrelling* makes a refreshing change from those lovers' tiffs so beloved of Victorian painters, set among rosy-cheeked peasants in the countryside.

With *Waiting for the Ferry at the Falcon Tavern* (75) we are back in the East End of London, in the territory which Tissot had already explored in pictures like *The Captain's Daughter* (58). This time, however, the protagonists are infinitely smarter, in particular the haughty and immaculately fashionable lady in the centre, who seems to have strayed out of *The Ball on*

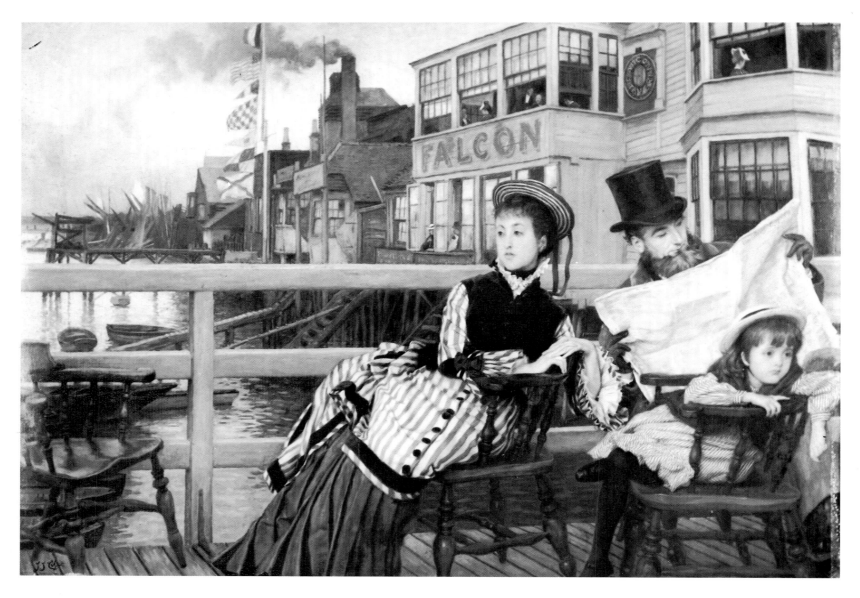

Shipboard; indeed she also appears in that picture and *London Visitors*. Tissot was to repeat the theme of figures on a jetty many times, and it was a particularly favourite setting for pictures of himself and Mrs Newton. Also reminiscent of the festive atmosphere of *The Ball on Shipboard* are *Still on Top* (77) and *A Fête Day at Brighton* (76) in which Tissot further indulges his passion for flags and striped dresses.

Tissot's reputation in England as a portrait painter was enhanced in 1874 with the most important of his portrait commissions, *The Empress Eugénie*

75 *Waiting for the Ferry at the Falcon Tavern*, c1874.

76 *A Fête Day at Brighton*, c1875–8.

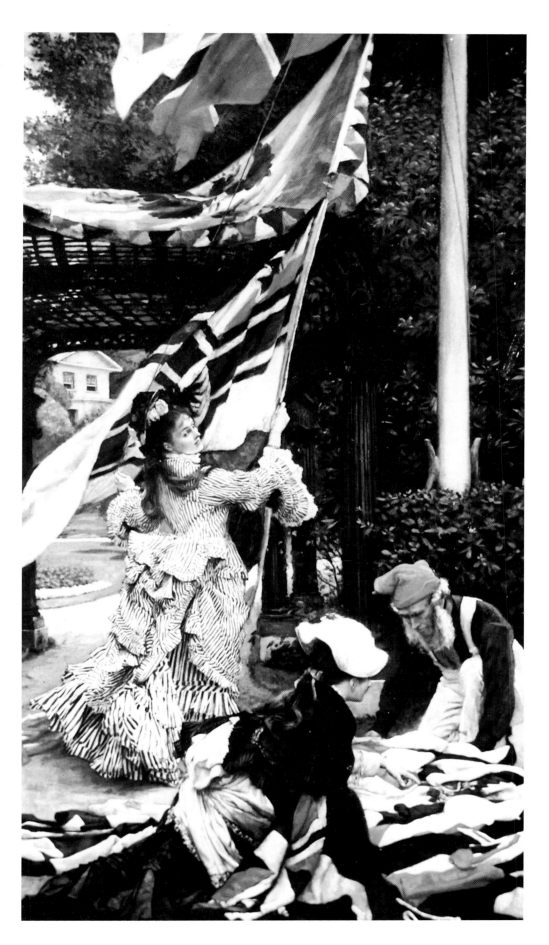

77 *Still on Top*, c1874.

and the Prince Impérial in the Grounds of Camden Place, Chislehurst (78). The picture, which now hangs in the Château de Compiègne in France, is one of Tissot's most historically interesting portraits. As a portrayal of a once-great family living in reduced circumstances, it is both sympathetic and subtle. The sorrowful figure of the Empress Eugénie, once a great beauty and the centre of a glittering court, is tenderly portrayed as a resigned widow in her weeds. Her son's lack of physical presence is boosted by his smart uniform of a Woolwich cadet and his cheerful bearing. Both now appear more poignant with the knowledge that the Prince was killed in the Zulu Wars only a few years later. The autumnal colours add to the mood of wistful despair; in the background hover the shadowy figures of courtiers. As a portrait of royalty it is one of the most remarkable performances of the nineteenth century. The setting suggests bourgeois respectability, and yet the Empress has an unmistakable air of exiled royalty. The picture also conveys pro-Bonapartist sympathies, and would therefore argue against Tissot's supposed involvement with the Commune in 1871, only three years previously. Could a Communard sympathiser have painted such a picture? Or was it just another commission as far as Tissot was concerned?

78 *The Empress Eugénie and the Prince Impérial in the Grounds of Camden Place, Chislehurst*, c1874.

By 1876 Tissot could look back on five years of extraordinary success in London. From a penniless exile, he had established himself as one of the most successful and popular artists in London. In 1872 he left the hospitable roof of Thomas Bowles for a house at 73 Springfield Road, St John's Wood, an area popular with artists and kept women. The following year he moved to nearby 17 Grove End Road, which was to remain his London home until 1881. When word of Tissot's success reached Paris, his friends were agog. Degas wrote, 'I hear you've bought a house. My mouth is still open.' Edmond de Goncourt, as one might expect, was more sarcastic, and noted in his Journal for 3 November 1874, that 'Tissot, this plagiarist painter, was having the greatest of successes in England. Has this ingenious exploiter of English stupidity not come up with the idea of an ante-room to his studio perennially filled with iced champagne for his visitors, and around his studio a garden where one might observe at all times a footman occupied in dusting and polishing the leaves of the laurel bushes?' Berthe Morisot visited London with her husband in 1875 and was invited to dinner at Grove End Road. She wrote to her mother afterwards that Tissot 'is very well set up here, and is turning out very pretty pictures. He sells them for 300,000 francs a time. So what do you think of success in London? He was very kind; and complimented me on my work, though I doubt if he has actually seen any.' In another letter to her sister she wrote that 'Tissot ... is living like a prince ... he is very kind, and most amiable, though a little common ... I paid him a great many compliments and truly deserved ones.' One suspects that the fastidious Miss Morisot found most people 'a little common'.

Tissot's success in London is all the more remarkable when one contrasts it with the struggles of other French exiles. Giuseppe de Nittis, for example, was conspicuously unhappy and unsuccessful during his stay in London. He hated the climate, disliked the food, could not cope with the language, had difficulties with both his clients and dealers, and in spite of this painted some memorable street scenes of London. Tissot, on the other hand, spoke good English and slipped effortlessly into artistic circles. An enamel plaque dated 1886 was inscribed by Tissot with the names of his English friends: at the head of the list came Louise Jopling, a fellow artist and a great beauty, well-known in London society in the 1870s and 80s, who with her sister was among Tissot's earliest friends in London. She had studied in Paris and spoke fluent French, which Tissot doubtless appreciated. In her memoirs, *Twenty Years of My Life*, published in 1925, she wrote of Tissot's great success with *Too Early*, and remembered that he was 'a charming man, very handsome, extraordinarily like the Duke of Teck ... He was always well groomed, and had nothing of artistic carelessness either in his dress or demeanour. He admired my sister Alice very much, and he asked her to sit to him, in the pretty house in St John's Wood, which afterwards became the home of Sir Lawrence Alma-Tadema ... At one time James Tissot was very hospitable, and delightful were the dinners he gave. But these ceased when he became absorbed in a *grande passion* with a married woman, who, to his great grief, died after he had known her but a brief time.' Later Mrs Jopling and Tissot lost touch so completely that she wrote in her memoirs that he had become a Trappist monk, a myth that lingered on for years afterwards.

The other artists and friends on the list are a curious mixture, a complete cross-section of artistic circles, including George du Maurier, the celebrated

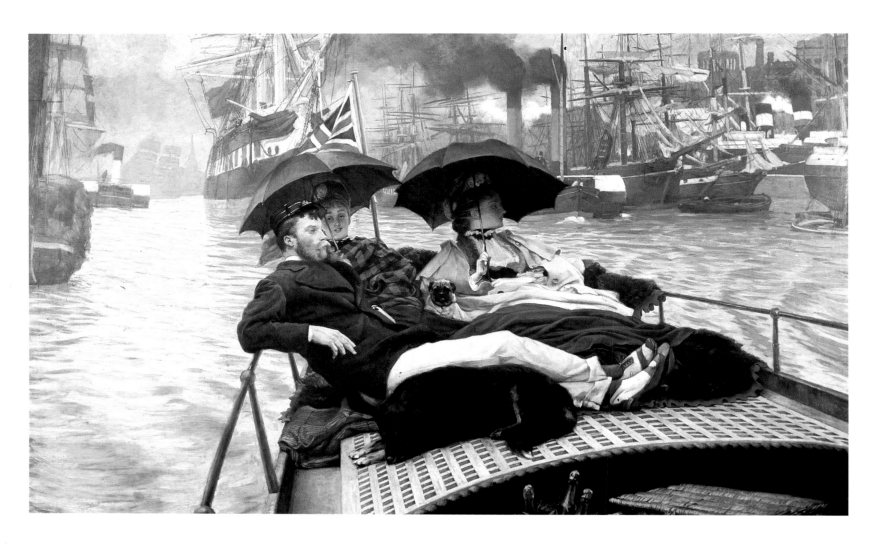

79 *The Thames*, c1876.

novelist and Punch cartoonist, Phillip Richard Morris RA, Whistler and his brother-in-law Seymour Haden, the celebrated etcher, Millais, Charles Napier Hemy, who had also studied under Leys in Antwerp, Clara Montalba, Robert Walker Macbeth, Sir Jules Benedict, the composer and conductor, and William Eglinton, the celebrated spiritualist and medium, later to play an important and sinister role in Tissot's career. Many of these artists belonged to the Arts Club in Hanover Square, of which Tissot was a member from 1873 to 1884. The club was a kind of junior Royal Academy; banquets were given when one of its members was elected an Academician. Phil Morris, du Maurier, Whistler, Seymour Haden, Millais, R.W. Macbeth and Sir Jules Benedict were all members, and the club also provided a welcome haven for foreign artists, including Carlo Pellegrini, Tissot's fellow-cartoonist on *Vanity Fair*, Ferdinand Heilbuth and Giuseppe de Nittis. The diary of Alan S.Cole, son of Henry Cole of the South Kensington Museum, records two dinners with Whistler in 1875:

November 16
Dined with Jimmy; Tissot, A. Moore, and Captain Crabb. Lovely blue and white china and capital small dinner. General conversation and ideas on art, unfettered by principles. Lovely Japanese lacquer.
December 7
Dined with Jimmy; Cyril Flower; Tissot; Storey. Talked Balzac.

A.Moore is of course the painter Albert Joseph Moore, close friend and associate of Whistler at this period; and Cyril Flower, later first Lord Battersea, was a noted collector and patron, particularly of Whistler and Frederick Sandys.

Clearly by 1875 Tissot was an accepted and well-known figure in social circles. In 1876, however, two events occurred which were to change the course of his English career. The first was the hostile reception of one of his pictures at the Royal Academy. At the 1876 Academy he exhibited two etchings and two pictures. The first picture, *A Convalescent* (73), has already been mentioned. The second, which caused so much offence, was *The Thames* (79), showing a jaunty naval officer accompanying two smartly dressed ladies on a boat trip round the Pool of London. Tissot had already explored the theme of a sailor and two ladies in *Boarding the Yacht* of 1873, which had not given offence. *The Thames*, however, seemed to strike Victorian morality on a very raw nerve, and the reaction of the critics was violent. The *Athenaeum* thought it 'thoroughly and wilfully vulgar' and described the two ladies as 'ugly and low-bred'; the *Spectator* went further, accusing them of being 'undeniably Parisian ladies', obviously in Victorian terms the worst thing you could possibly say about a lady. 'Questionable material', thundered *The Times*. Even the *Graphic*, normally a strong supporter of Tissot, complained that it was 'More French, shall we say, than English?' Tissot was probably amazed by the critics' reaction. But J. C. Horsley had encountered just the same problem in 1860 when he had exhibited *Showing a Preference*, with a naval officer accompanying two pretty girls through a cornfield; and even earlier, in 1854, a storm of abuse greeted Abraham Solomon's picture *First Class – The Meeting*, showing a young man chatting to a pretty girl in a railway carriage while her father slumbers. Solomon even went to the lengths of painting a second, more acceptable, version. By the same token, the Victorian audience clearly found Tissot's picture vulgar, improper and, even worse, French. Anti-French feeling is often detectable in criticisms of Tissot's pictures, and never more so than with the luckless *Thames*. It certainly warns us against falling into the trap of imagining that Tissot is the perfect mirror of Victorian society: to his contemporaries his pictures were clearly exotic, flashy and satirical, and his characters were simply too smart to be respectable. Tissot continued nevertheless to paint pictures on the same theme as *The Thames*. A very similar picture entitled *Portsmouth Dockyard* (96) shows a Highlander in a boat with two pretty girls, and at about the same time, c1877, he painted *The Gallery of H.M.S. Calcutta* (95), again showing a naval officer on board ship with two attractive ladies. But the débâcle of *The Thames* marked the effective end of Tissot's relationship with the Royal Academy. Except for two pictures in 1881, his last year in London, he did not exhibit there again, and transferred his affections to the newer and more advanced Grosvenor Gallery, which opened in 1877.

The other momentous event of 1876 was his meeting with the woman whose name was to become inextricably linked with Tissot's life and his art, Kathleen Newton, and it is to her short and tragic life that we must now turn.

LONDON
1876-1882

The Painter of Love

Who was the attractive and stylish lady who began to appear in so many of Tissot's pictures after 1876? Known simply as 'la mystérieuse' or 'la belle Irlandaise', her identity remained a mystery until well into this century. The truth only began to emerge in 1946 when Marita Ross, an English journalist, tracked down Lilian Hervey, Kathleen Newton's niece, who as a girl appears in many of Tissot's pictures of life in Grove End Road. Although only seven when her aunt died, Lilian Hervey had five photographs of Tissot and Mrs Newton in her possession, and gradually the biographical facts about Kathleen Newton's brief life began to emerge.

80

By the Thames at Richmond, c1878–9.

Born Kathleen Irene Ashburnham Kelly in 1854, she was brought up by her father, Charles Kelly, an Irish army officer who served with the Indian Army. Like Tissot, she was a Catholic. After a convent education, at the age of seventeen she was sent to India to marry Isaac Newton, a surgeon in the Indian Civil Service. On the voyage out, however, she had an affair with a certain Captain Palliser, which she confessed to Newton immediately after their wedding on 3 January 1871. Newton's response was to institute divorce proceedings in May 1871. The case was undefended, and a decree nisi granted on 20 December of that year. By 20 July 1872 a decree absolute was obtained, and the marriage was at an end. In one of her few surviving letters, written at the time of the divorce, Kathleen Newton confessed to her husband, 'I am going to speak to you as if I were standing before God. It is true that I have sinned once, and God knows how I love that one [Palliser] too deeply to sin with any other.' The naïve and pious tone of the letter is what one might expect of a convent girl of only seventeen years of age. She remains a rather shadowy figure, perhaps a typical victim of an early arranged marriage; a heroine who might have stepped out of the pages of many a Victorian novel. Of her seducer, Captain Palliser, nothing more is heard; with doubtless unconscious irony, the Oxford University Press World Classics series have recently started using Tissot's pictures on the covers of the Palliser novels by Trollope.

During 1871 Kathleen Newton returned to England, and on the day the decree nisi was granted gave birth to her daughter by Captain Palliser, Muriel Mary Violet. She then went to live with her sister and brother-in-law Mary and Augustus Frederick Hervey, a colonel in the Indian Army, at 6 Hill Road, St John's Wood, near Tissot's house in Grove End Road, but it is not known exactly when the two met or how. All we do know for certain is that in March 1876 Kathleen Newton gave birth to another child, a son, who she christened, surprisingly, Cecil George Newton. It has often been assumed that Tissot was the father. This has never been conclusively proved, although both Violet and Cecil George are known to have visited Tissot later in Paris, and he left them both a thousand francs in his will. Both harboured mistaken ideas about their parentage, and laid claim to a share of the estate of Dr Isaac Newton. Very little is known about either of their later careers: Violet became a governess in Golders Green, and Cecil enlisted in the army and made a dramatic appearance at an exhibition of Tissot's work at the Leicester Galleries in London in 1933. Standing before a picture of Mrs Newton, he announced, 'That was my mother', stalked out, and was never seen or heard of again.

Recent research claims to identify the father positively as Tissot, but my own view is that Cecil George was not the son of Tissot and Mrs Newton. If that were the case, the two would have to have met in 1875, or earlier, but there are no pictures of Mrs Newton before 1876. And if Cecil George had really been Tissot's only child, he would surely have left him more money in his will. Under French law, a father can adopt an illegitimate son and leave him his property. But Tissot left his château and most of his estate to his French niece, which suggests that she was his nearest blood relative, not Cecil George. Who the second mysterious father could have been, history has not yet revealed for certain.

We do know, however, that in 1876 Kathleen Newton and her two

children moved into Tissot's house, and remained there until her death from consumption in 1882. It must have been a curious household – a French painter, an Irish divorcee, and two illegitimate children – and unconventional enough to be beyond the pale of respectable Victorian society. By allying himself with such a *déclassé* lady, Tissot must have known that he would henceforward be barred from participating in the kind of London social life he had hitherto enjoyed. The iron laws of Victorian hypocrisy dictated that you could certainly keep a mistress in St John's Wood, provided you did not flaunt her publicly or get into the newspapers. Tissot seems quite happy to have made the sacrifice. From her photographs and Tissot's many pictures of her it is clear that Kathleen Newton was a beauty. She must also have had the added attraction of the damsel in distress, the crushed rose, something which appealed greatly to the chivalrous streak in our Victorian forefathers. The fallen woman was one of the most potent images in Victorian art, and one which carried over into life. Many Victorian artists, such as William Morris and Frederick Sandys, married working-class girls, and while Kathleen Newton can hardly be called working-class, part of her appeal must have been her status as an unfortunate victim of the Victorian moral code, which dealt cruelly and unforgivingly with female offenders. For a fallen woman in Victorian England there was no way back. In addition, she was consumptive, and therefore a kind of Victorian *Dame aux Camélias*. This Victorian Violetta was thus to be immortalized through Tissot's art, joining the gallery of famous models of the time – Elizabeth Siddal, Jane Morris, Annie Miller and Dorothy Dene, to name but a few.

For Tissot it was obviously the happiest period of his life, and one which he was to look back on longingly for the rest of his days. For the first and only time in his life he was living the life of a family man, and although outlawed from London society, he was not without friends in artistic circles. He and Kathleen continued to see all his artist friends, and to move freely in less conventional circles. The change in Tissot's domestic life is also reflected in his art. After 1876 the emphasis begins to shift away from society life to more intimate domestic scenes. The settings become familiar and repetitive – interiors of the house and studio at St John's Wood, often with children at play; in the garden and around the pool; up and down the river to Richmond, Greenwich, Ramsgate and Gravesend. Over all of them presides the slim, elegant presence of Mrs Newton.

As with all such illicit relationships in the nineteenth century, one senses that the life of Tissot and Mrs Newton was an enclosed world, isolated and inward-looking. Tissot's obsession with Kathleen Newton, as with so many Victorian artists and their models, became neurotic, even tormented, especially as her illness began gradually to destroy her. Looking at his previous career, it might seem that Mrs Newton was simply the ideal model, the perfect vehicle for Tissot's art, in which feminine beauty and elegance play such a large part. In a way she was the woman he had been waiting for, and she walked into Tissot's pictures like an actress who had found the ultimate role. But in another sense she was a real *femme fatale* who changed the course of Tissot's life and his art. The relationship may have been stormy and occasionally difficult, but there can be no doubt that Kathleen Newton was the great love of Tissot's life.

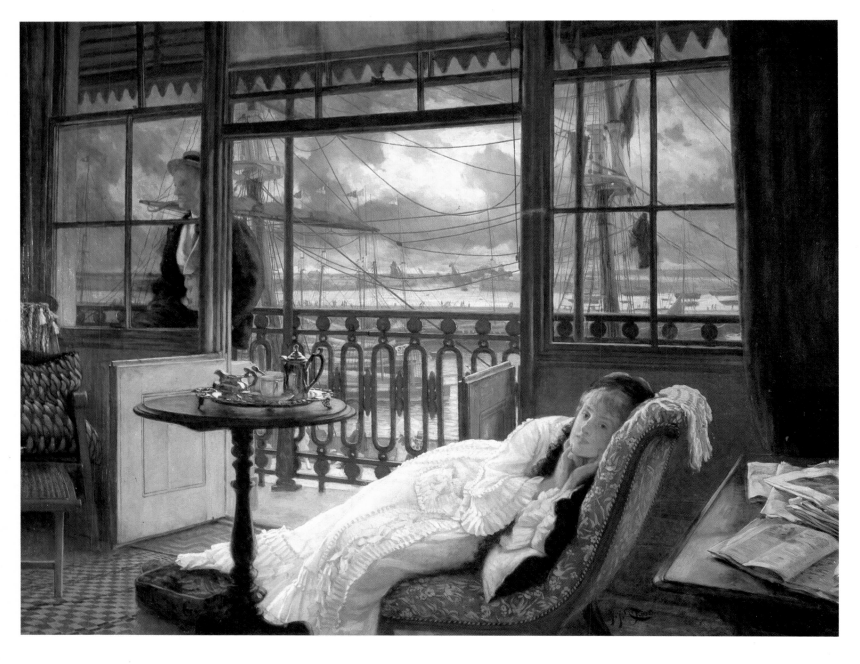

One of the first pictures in which she appears is *A Passing Storm* (81), painted some time in 1876 and set in a room overlooking Ramsgate harbour where Tissot painted many of his best seaside pictures. Mrs Newton lies on a chaise longue, in a pose combining elegant provocativeness and enigmatic insouciance. Outside on the balcony stands the figure of the lover, hands in pockets, looking restless and bored. It is the kind of trivial domestic narrative of which Tissot was the absolute master: out of two figures and a room overlooking a harbour he has created a picture that looks outwardly innocuous and yet is full of tension and suppressed emotion that cannot fail to draw the spectator's interest. Kathleen Newton appears again in another very similar picture, *Room Overlooking the Harbour* (82), sitting at a lunch table while an older man reads the newspaper. It is perhaps one of the most beautiful and subtle of all Tissot's narrative pictures of this period. Here, surely, it is not too romantic to suggest that Mrs Newton inspired Tissot to

81 *A Passing Storm, c*1876.

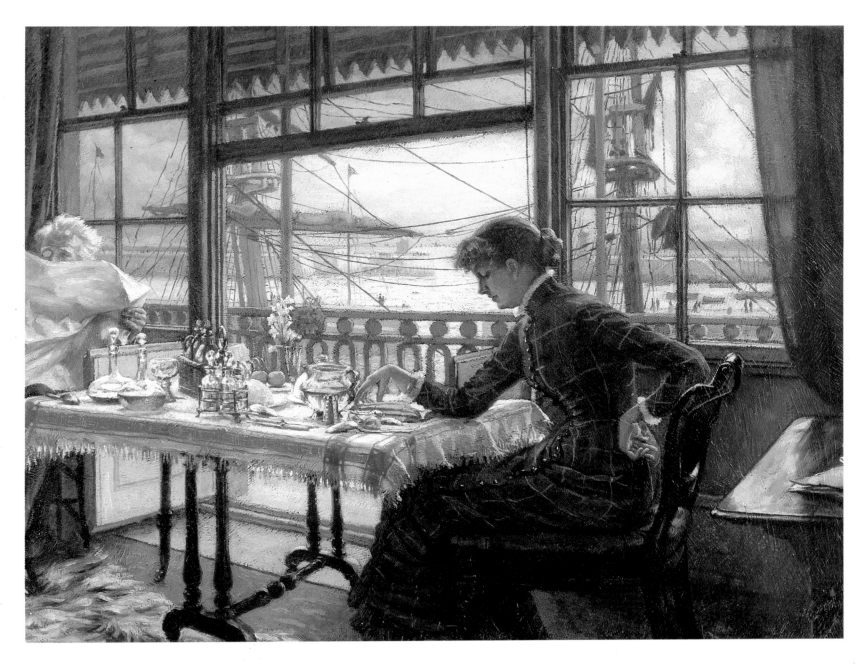

82 *Room Overlooking the Harbour, c1876–8.*

produce some of the finest of his English pictures. The delicate nuances and subtle suggestiveness of these pictures are even more successful than the earlier shipboard romances, such as *The Last Evening* (60) or *The Captain and the Mate* (61). The same room at Ramsgate was also the setting for one or two of his finest etchings (83).

During the late 1870s Tissot began to use photographs to help with his compositions. A number of photographs survive of Mrs Newton on her own (85, 87) and with Tissot and the children (89), all of which relate directly to later pictures. Mrs Newton sitting on some steps becomes *The Elder Sister*, which was both a painting and an etching, known as *La Soeur ainée* (84). Mrs Newton sitting on the grass wearing a hat, in profile, appears in *In the Sunshine* (86), also the subject of a very similar etching. A group photograph of Tissot, Mrs Newton, Cecil George, Violet and Lilian Hervey, became the basis of several compositions, and is echoed in particular in two pictures

83 *Ramsgate*, 1876.

84 *The Elder Sister* (*La soeur aînée*), 1881.

85 Photograph of Kathleen Newton and her niece,
Lilian Hervey, on the steps below Tissot's
studio and conservatory in Grove End Road.

84

85

86 *In the Sunshine* (*En plein Soleil*), c1881.

87 Photograph of Kathleen Newton in the garden
at Grove End Road.

entitled *Waiting for the Ferry* (88, 90), and in at least two sketches of Tissot and Mrs Newton by the Thames (80). In several of these the same little girl appears, seen from behind, wearing a hat and a large bow, holding on to a rail; in several others Tissot sits opposite her, staring vacantly but lovingly at his adored one; and in both of the ferry pictures Mrs Newton sits in the same Windsor chair shown in the photograph, wearing a hat or a veil. The faithful similarity of these pictures to the photographs is a fascinating reminder both of the uses to which Victorian artists put photography, and of the degree to which Tissot's life and his art at this period had become inextricably intertwined. To look at the photographs and the pictures side by side gives the viewer an extraordinary insight into Tissot's art, just as looking at photographs of Jane Morris reveals the art of Rossetti.

Mrs Newton also appeared in many pictures on the themes of sickness and convalescence which now occurred with increasing frequency, and were made all the more poignant by her own advancing illness. In *The Warrior's Daughter* (91) previously known as *The Convalescent*, it is not Mrs Newton who is ill, but the old warrior in the bath chair, being wheeled around Regent's Park. In later pictures, such as *Summer Evening* (122), Mrs Newton herself is the invalid, well wrapped in rugs and propped up with cushions, sitting in a wicker chair in the garden or the conservatory.

88 *Waiting for the Ferry*, c1878.

89 Photograph of Kathleen Newton and Tissot, with her niece Lilian Hervey, and son Cecil George, in the garden at Grove End Road.

At the same time scenes of travel and departure become more common, and the underlying mood of transience and sadness becomes even more pronounced. In some, such as *By Water* (92), Mrs Newton is depicted as the elegant traveller, waiting at the dockside. In others, such as *Goodbye, on the Mersey* (114), the ship is shown leaving, while a crowd waves from a smaller boat. But in many more pictures Mrs Newton is shown simply as a single figure engaged in some activity, or as an idealized portrait. In these there is no sign of sickness or unhappiness. In *October* (101) or *Spring (Specimen of a Portrait)* (102) we see a pretty and elegant woman in a garden, dressed with all the smooth perfection of a fashion plate. Many of the most delightful of these pictures show Mrs Newton in the garden of Tissot's house, as in *The Gardener* (112), still sadly a lost picture. These are some of the happiest of all Tissot's creations, reflecting his own contentment. They conjure up images of relaxed domesticity, of afternoons spent lazing and picnicking in the garden with the children, of games of croquet, conversations under trees,

90 *Waiting for the Ferry*, c1878.

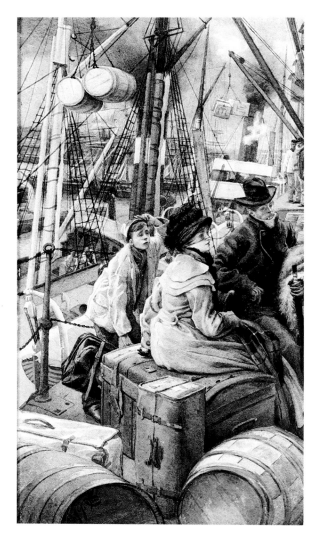

92 *By Water*, c1881–2.

91 *The Warrior's Daughter*, c1887.

and reading in hammocks. They are made even more touching by the knowledge that this spell of domestic bliss was only to be a brief interlude. Death and departure were not only themes for pictures, but a real threat hanging over this pair of doomed lovers.

The arrival on the scene of Mrs Newton coincided with another remarkable burst of creative activity from Tissot. Following the very unfavourable reception of *The Thames* at the Royal Academy in 1876, he transferred his loyalties to the newly-founded Grosvenor Gallery. The brainchild of Sir Coutts Lindsay, an amateur painter, and his Rothschild wife Blanche, this was intended as a forum for more advanced artists, both English and European, and as an alternative to the powerful monopoly of the Royal Academy. The purpose-built galleries in Bond Street were spacious and opulent, and were the first in the world to have electric lighting. Each artist's work was carefully hung in groups, well spaced out, in direct contrast to the random jumble of the Academy's walls. The social connections of the Lindsays and the attendance of the Prince and Princess of Wales at the opening in 1877 ensured a brilliant success: although it only existed for thirteen years it played a very important role in the development of late Victorian art.

The opening exhibition made the reputation of Burne-Jones, whose work had not been seen in public for several years. Whistler also exhibited several pictures, including the fateful *Falling Rocket* which so aroused the ire of Ruskin, who described it as 'cockney impudence' and was promptly sued by Whistler. In the ensuing trial, which bankrupted Whistler and awarded him a farthing damages, Tissot refused to testify as a witness, bringing their friendship to a sad end. The rivalry between the Academy and the Grosvenor was conducted in a typically English spirit of fair play, and several artists, including Lord Leighton and Alma-Tadema, managed to exhibit at both places.

93 Study for *Triumph of Will: The Challenge.*

Tissot, like Burne-Jones, showed no fewer than ten works at the 1877 exhibition, several of which are now lost, and their variety and quality impressed many of the critics. The most remarkable of the ten, entitled *The Challenge*, was intended to be the first of a set of five pictures called *The Triumph of Will*. The catalogue describes this as 'A Poem in Five Parts', the others being *Temptation*, *Rescue*, *Victory* and *The Reward*. *The Challenge*, which is now lost, depicted the Will, attended by two pages, Audacity (active) and Silence (passive) triumphing over Vice and Temptation. Only a drawing of one of the figures survives, showing a young girl draped in a tiger skin and holding a spear (93). It represents Tissot's only attempt to produce the kind of ideal, high art which the Grosvenor was attempting to sponsor; he is known to have greatly admired Burne-Jones, but to try and emulate his mystical, allegorical style was clearly a mistake. The critics were mystified, and the *Spectator* thought it resembled 'a scene from an inferior burlesque'. Only Ruskin thought it showed promise of higher things, and suggested that 'if he would obey his graver thoughts' he could do 'much that would, with real benefit, occupy the attention of that part of the British public whose fancy is at present caught only by Gustave Doré'. Ruskin's judgement, as usual at this period, was unreliable, and we can only be thankful that Tissot did not follow his advice.

The other pictures exhibited at the Grosvenor fall into more familiar categories. *A Portrait* (94) now known as *Miss Lloyd*, was presumably included as a specimen of Tissot's abilities as a portrait painter. It is indeed one of his smartest and most elegant creations, and for once not a portrait of Kathleen Newton. The sitter is a model, and the dress one of Tissot's studio

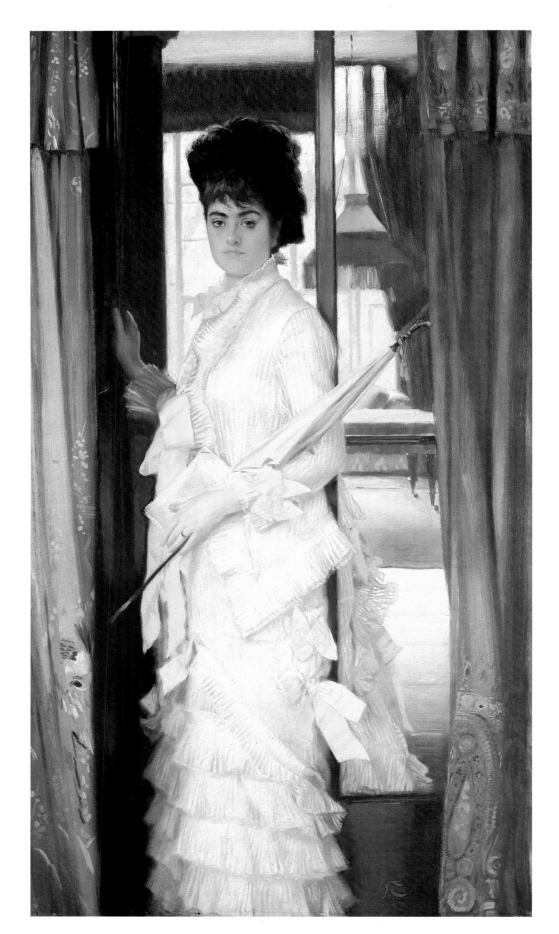

94 *A Portrait (Miss Lloyd)*, 1876.

95 *The Gallery of H.M.S. 'Calcutta'
(Portsmouth)*, c1877.

96 *Portsmouth Dockyard (How happy I could be
with either) (Entre les deux mon coeur balance)*, 1877.

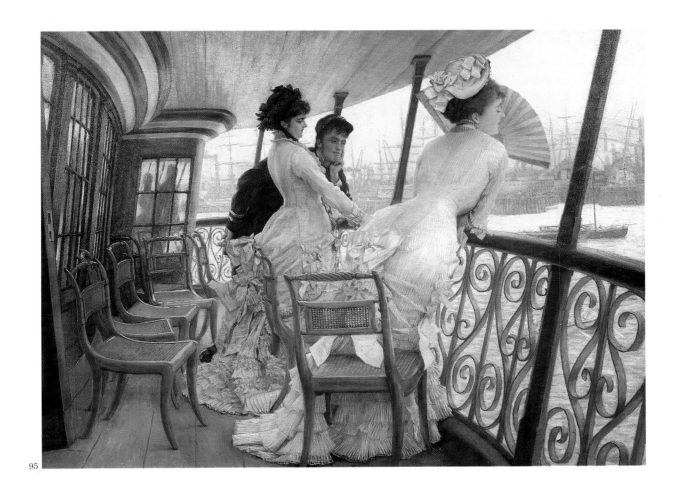

95

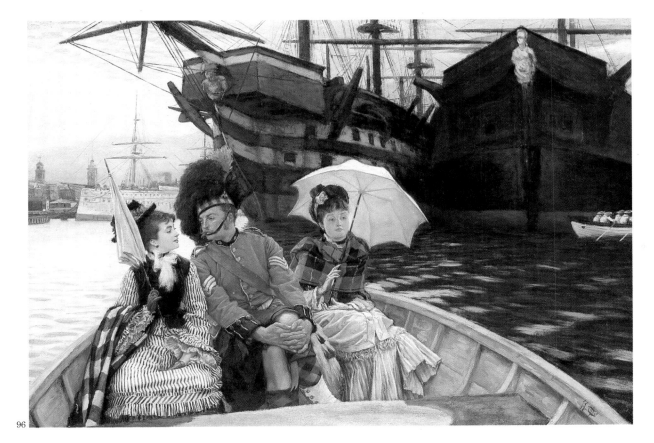

96

props. It did not, however, seem to produce many portrait commissions, as was doubtless intended. Two more river scenes were included, *The Gallery of H.M.S. Calcutta* (95) and *Portsmouth Dockyard* (96). Both pictures repeat one of Tissot's favourite devices, a man with two ladies. The *Calcutta* is the last and one of the most brilliant of his shipboard scenes. As in *The Ball on Shipboard*, the scene is set away from the ball itself, concentrating instead on the minor drama of a naval officer talking to two ladies leaning over the rail of the ship. The naval officer, just like J.C.Horsley's officer in *Showing a Preference*, is clearly attracted to one of the ladies, who here hides demurely

97 *The Widower* (*Le Veuf*) (small version), *c*1877.

98 *Holyday* (*The Picnic*), c1876.

behind her fan. The poses and dresses of the two ladies are memorably beautiful (the hourglass figure of the right hand lady has suggested to some that the title is a pun on the French *quel cul tu as*). The uneasy triangular relationship of the figures is brilliantly echoed in the composition, which is one of the most arresting Tissot ever painted. In particular the slope of the ship itself seems to throw the whole picture off balance, as does the irregular row of chairs. An air of sultry sensuality hangs over the whole scene, heightened by the pale, chalky colours and the glassy water of the harbour. Tissot again shows himself the master of the oblique narrative picture; out of a few simple elements he has created a scene full of tension and mystery.

The opening exhibition of the Grosvenor, as one might expect, was reviewed by a great many critics, few of whom had a good word to say for Tissot's *Calcutta*. Henry James dismissed it as 'hard, vulgar and banal', and claimed that he would not be able to live with it for a week without finding it 'intolerably wearisome and unrefreshing'. All painters of modern life in the

99 *Algernon Moses Marsden*, 1877.

Victorian period were the victims of critical abuse, but Tissot seems to have suffered more than most. Surprisingly, his other nautical offering, *Portsmouth Dockyard* (96) failed to arouse much critical attention, even though its subject matter was exactly the same as the offending *Thames* of 1876. Perhaps the substitution of a kilted Highlander for the naval officer proved more reassuring to the Victorian public. Tissot must indeed have been mystified by the vagaries of Victorian taste.

Two of Tissot's other pictures at the 1877 Grosvenor were set in his own garden, *The Widower* (97) and *Holyday* (98), now known as *The Picnic. The Widower* fared the better of the two with the public, probably because of its simple but arresting composition, and suggestively sentimental title. *Holyday*, although another of Tissot's most brilliantly stylish pictures, was not very well received, and earned the distinction of a critical review by Oscar Wilde. He dismissed it as a picture of 'over-dressed, common-looking people', and complained of the 'ugly, painfully accurate representation of modern soda-water bottles'. These bottles, lying on their side, are to the twentieth-century viewer a picturesque curiosity. Perhaps we would have the same difficulty as Oscar Wilde if confronted with an ugly, painfully accurate picture of a portable radio. At least the men's cricket caps have not

changed since Victorian times. They are those of I Zingari, a well-known old Etonian cricket team that survives to this day. Tissot's house was of course close to Lord's cricket ground, where he may have taken the opportunity to study this mysterious English sport.

Tissot did paint one or two portrait commissions at this period, including *The Chapple-Gill Family*, a charming if rather bland picture, and a much more arresting portrait of his art-dealer friend *Algernon Moses Marsden* (99)

100 *Henley Regatta, 1877,* 1877.

in Tissot's studio, surrounded by art objects. This is one of the best portraits of an art dealer and connoisseur painted in the Victorian period.

Another commission of this period is *Henley Regatta, 1877* (100), so untypical of Tissot's output that its authenticity, though well documented, has been questioned by some. Instead of concentrating on a small group of figures, Tissot has here given us a panorama, painted in a fluid, Impressionist style reminiscent of Monet, Renoir or Boudin.

At the 1878 Grosvenor exhibition Tissot was again present in force, with a further nine pictures, five of them etchings. The extent to which Mrs Newton was dominating his life and art by this time is evinced by her appearance in no fewer than five of the nine pictures. She was the model for three paintings: *October* (101), *Spring (Specimen of a Portrait)* (102), and *July (Specimen of a Portrait)* (103), of which two versions exist. Of these the most striking is *October*, an unusually large picture for Tissot. Mrs Newton is dressed in the height of fashion, swathed in black frills and furs, and trips enticingly away from the spectator, looking invitingly back over her shoulder. The background is a brilliantly colourful tapestry of brown chestnut leaves, with the light filtering through them, a particularly English autumnal effect which he repeated in many pictures. In *Spring*, a

101 *October*, 1877.

103 *July* (*Specimen of a Portrait*), c1878.

102 *Spring* (*Specimen of a Portrait*), c1878.

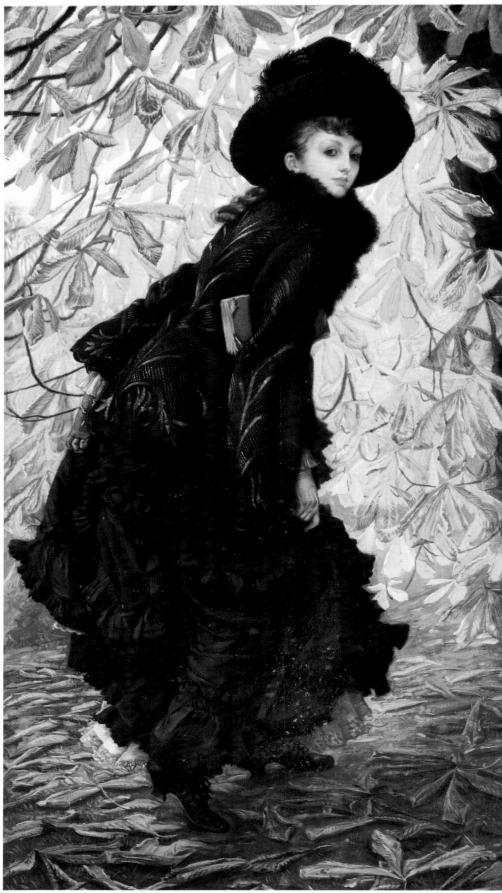

101

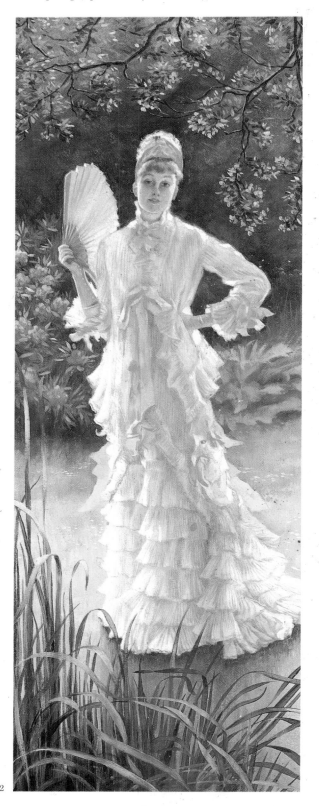

102

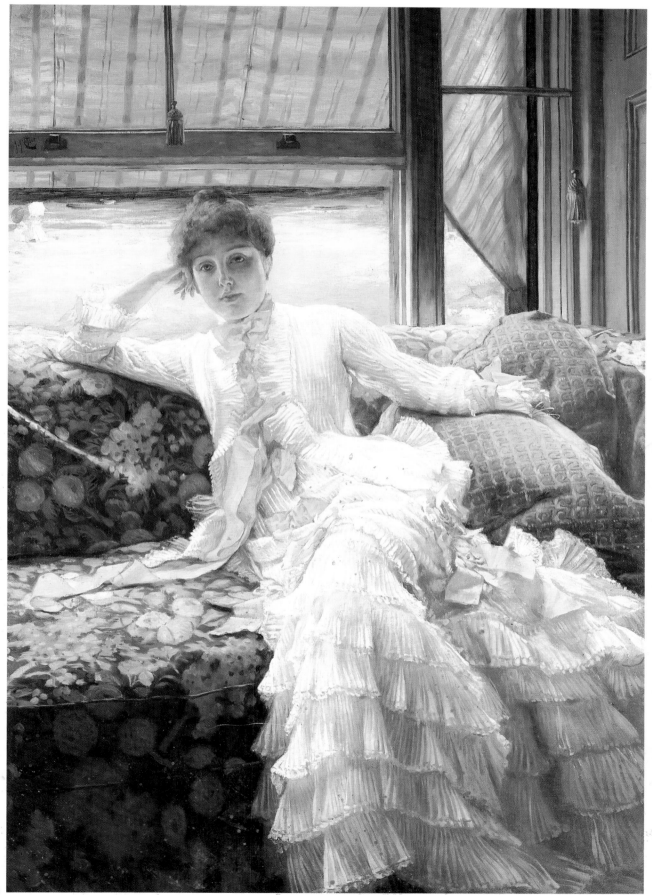

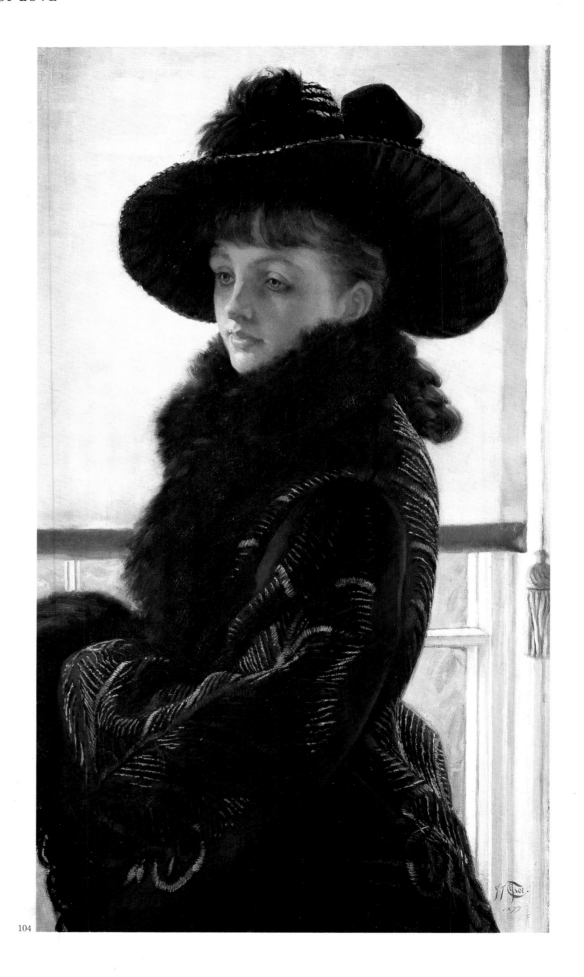

104

104 *Mavourneen* (Portrait of Kathleen Newton), 1877.

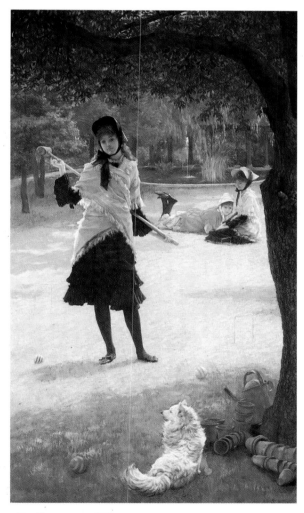

105 *Croquet*, c1878.

much smaller picture painted on paper, she appears in a white dress with yellow ribbons, already seen in the portrait of Miss Lloyd the year before. In *July* she is in the same dress, but reclining gracefully on a floral-patterned sofa with a view of the seaside through the window behind her.

All three of these portraits have been cited as evidence of the influence of the English painter, Albert Joseph Moore, a close friend of Whistler and a fellow-exhibitor at the Grosvenor. The use of single-figure images, the concentration on harmonies of colour, and in the case of *October* the size of the canvas, can all be cited as showing Moore' influence. The pose of *July* is obviously similar to that of many of Moore's sleeping and reclining figures, but the insistent modishness of Tissot's figures is a long way from the aesthetic Parnassus of Albert Moore. If Moore's models look Graeco-West Kensington, then Tissot is Parisian-St John's Wood.

Mrs Newton appears in a similar costume in one of the etchings of 1878, *Mavourneen*, of which there is also a version in oils (104). With typical shrewdness Tissot took the title from a popular song, and it proved to be the most popular of all his etchings. Etchings form a considerable part of Tissot's London output: he had experimented with the method in Paris in the 1860s, but it was not until about 1875 that he began to make regular use of it. It is generally assumed that he was influenced by the etchings of Whistler and his brother-in-law, Seymour Haden, and with his unerring nose for fashion, he must also have noted the increasing vogue for etching during the 1870s. The *catalogue raisonné* of Tissot's prints lists eighty-four different subjects, the majority of them etchings, and a few mezzotints. Most are simply reproductions of or variations on subjects already explored, or later explored, in oil, for Tissot used his prints mainly to exploit and disseminate images already conceived in oil. Sometimes, however, they vary slightly from the paintings, and there are cases, as with *Mavourneen*, where the etching seems to have come first.

Although he may not have been a very original print-maker, Tissot was certainly a master of the mediums of etching and drypoint. His work is of uniformly high quality, and is now avidly collected by both print collectors and those who appreciate Tissot but are unable to buy his oils. Like many Victorian painters, Tissot was also not above producing small replicas of his own work, both in watercolour and in oil (sometimes these replicas are all that have survived, which at least makes them useful to historians). He also sometimes changed the titles of his pictures, especially if they did not sell: there are several cases of the same picture being exhibited with different titles, which has led to many confusions that are only now being unravelled.

Croquet (105), the fourth picture exhibited at the Grosvenor in 1878, is perhaps the most enchanting of all Tissot's images, and also the subject of a favourite etching. In the foreground stands a slim young girl, dressed simply in a short skirt, shawl and hat, coyly barring our way with the croquet mallet held behind her back, while Mrs Newton and the children play on the lawn behind her. We have the sense of trespassing in a private, enclosed world, a kind of secret garden. The objects in the foreground also seem to bar the way – a dog, a ball, flowerpots and a watering can. Tissot himself must have been fond of this image, as he made an etching of it, and repeated the subject on one of his *cloisonné* enamel vases. Very different, and much less intimate, is *The Letter* (106), also set in a garden, in which an imperious lady

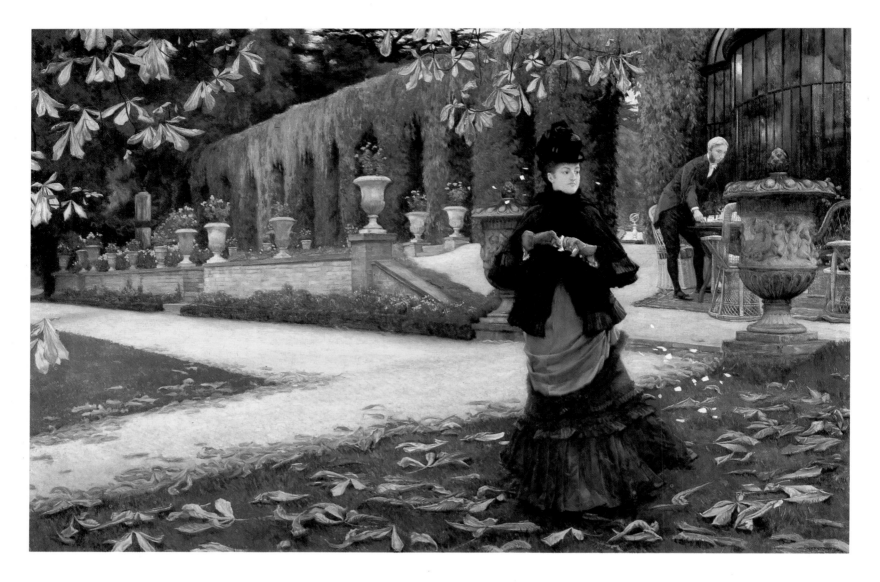

106 *The Letter (La Lettre)*, c1876–8.

tears up a letter in a decidedly forceful manner. Letters were a favourite
device in both Victorian narrative pictures and novels, and this lady could
well represent one of Trollope's grander heroines. In the background a
servant clears the tea-table, perhaps the same footman so sarcastically
described by de Goncourt as polishing the laurels.

In 1879, the last year in which Tissot was to exhibit at the Grosvenor, he
appeared with renewed brilliance, exhibiting no fewer than twelve pictures,
eight oils and four etchings. Mrs Newton was once again the reigning muse,
but unfortunately several of the pictures in which she appears have now
disappeared, in particular *The Rivals*, which shows her seated in a
conservatory, clearly charming two attentive old gentlemen over the tea-
table. The *Athenaeum* described this as 'a clever but rather coarse painting
of unpleasant persons seated at afternoon tea'. Similarly offensive remarks
might well have been directed at *In the Conservatory* (107) which has often
been confused with *The Rivals*. Here is another of Tissot's triangular
comedies of manners, as two winsome sisters in blue compete for the charms
of a lone male, who seems to seek refuge beside their mother. The
background is the same brilliantly lush display of tropical plants as in *The
Bunch of Lilacs*.

Mrs Newton was the model in two other lost paintings, *A Quiet Afternoon* (108) and *The Hammock* (109), also known through an etching. Both aroused the wrath of the critics. It was of course by this time common knowledge in the art world that Tissot was living openly with a divorcee and her children, and a distinct note of moral disapproval, spiced with envy, begins to enter the reviews at this period. The fact that Tissot had impudently challenged public opinion by flaunting his private life in public seemed to strike the English critics on yet another raw nerve. The *Spectator* set the tone: 'This year he tries our patience somewhat hardly, for these ladies in hammocks, showing a very unnecessary amount of petticoat and stocking, are remarkable for little save a sort of luxurious indolence and insolence...' *Punch* was witty at the expense of both pictures, satirizing *The Hammock* in a doggerel poem called 'The Web', all about 'The Spider and the Fly', with sly references to neat ankles and pretty boots. The implication seems to be that it was bad enough of Tissot to have a mistress, and worse still to be plainly enjoying it.

107 *In the Conservatory (The Rivals)*, c1875–8.

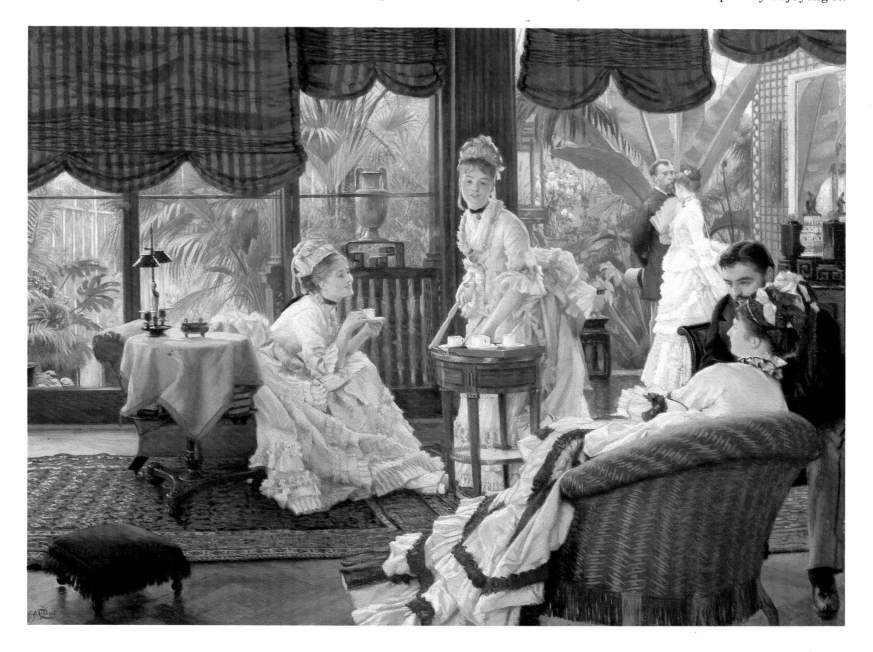

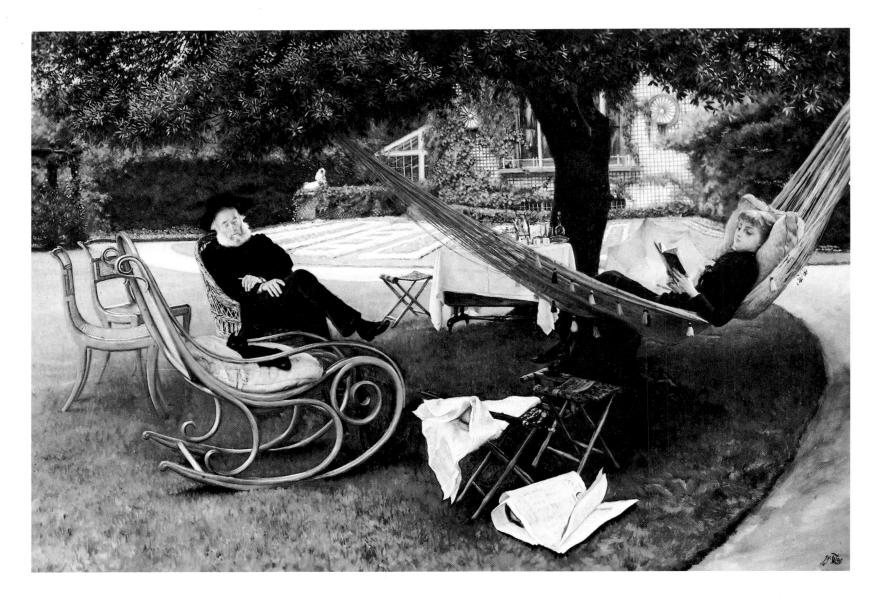

108 *A Quiet Afternoon*, c1879.

An unmistakable note of jealousy running through these reviews betrays the critics' real feelings. The *Punch* reviewer allowed his imagination to run away with him over *A Quiet Afternoon*, maliciously renaming it *The Naughty Old Man*; or *I'll tell your Wife how you spend your Afternoons in Fair Rosamund's Bower-Villa N.W.* Another picture, *Going to Business* (110), was tagged with a malicious poem:

> Drive on, Cabby!
> Ah, is she good,
> She of the Abbey
> Road, St John's Wood?

In fact, both *A Quiet Afternoon* and *Going to Business* are among Tissot's best London pictures. *Going to Business* is especially unusual, being a street scene, with St Paul's in the background, in the narrow upright format which Tissot increasingly favoured at this period.

But the *Spectator* and *Punch* reviews are indicative of the general hostility which Tissot's pictures were arousing by the end of the decade. Another Grosvenor exhibit, *Orphan* (111), also met with critical contempt.

109 *The Hammock* (*Le Hamac*), 1880.

110 *Going to Business* (*Going to the City*), c1879.

111 *Orphan (L'Orpheline), c*1879.

112 *The Gardener*, c1879.

Tissot clearly intended it as a pendant to the successful *Widower*, but this time he struck the wrong note; the reviewer of *The Times* thought the setting of tall reeds suggested 'nothing short of suicide and the muddiest of deaths', while others criticized the harshly monochromatic blacks and greens, which they compared to Whistler's 'arrangements'. Although orphans were a favourite subject with Victorian artists, Tissot's figures were clearly not sentimental enough for contemporary taste, and both figures also look suspiciously well-dressed, suggesting that they have been well provided for and do not therefore deserve our sympathy. These trivial

113 *Mrs Newton with a Parasol*
(*Mme Newton à l'ombrelle*), c1879.

considerations apart, however, it is a very striking image, particularly because of its size: like *October*, it is unusually large for Tissot, and it also repeats the same background of yellowing chestnut leaves.

Also from 1879 is *The Gardener* (112), a lost picture, and yet another variation on the St John's Wood garden idyll. Mrs Newton holds the same oriental parasol in the monumental portrait *Mrs Newton with a Parasol* (113), the grandest and the most stylized of all Tissot's pictures of Kathleen Newton. Reminiscent of some of Whistler's full-length portraits, it exploits a deliberately Japanese simplicity of design and abstract background colouring. The face too is idealized and statuesque. This is surely one of Tissot's finest images, a veritable icon of elegance. It is as much a hymn to feminine beauty as Rossetti's haunting pictures of Jane Morris, many of which were painted in the same decade: in spite of their differences, Tissot and Rossetti were worshipping at the same shrine, twin devotees of the Victorian cult of forbidden love.

Perhaps because of the mounting criticism of his pictures, Tissot did not exhibit again at the Grosvenor after 1879. Indeed, during 1880 he did not exhibit in public at all, perhaps because of his continuing obsession with Mrs Newton, and perhaps also because he was by this time prosperous and well-known enough to get by on private sales and commissions. In 1881 he made a surprising return to the Royal Academy, exhibiting two pictures, *Goodbye, on the Mersey* (114) and *Quiet* (115). The former, as already mentioned, is one of the most sombre of all his pictures of travel and departure, full of muted browns and greys; and *Quiet* is among the most beautiful and haunting of all his pictures of Kathleen Newton. Looking elegant but pale, she sits on a bench in the garden at St John's Wood, with her niece Lilian Hervey beside her. Next to them is a dog, already seen in the notorious picture *The Hammock* (109), and thrown over the bench is a leopard-skin rug, which also made an appearance in several other pictures. The picture is moving because of the suggestion of convalescene in the pale and slightly haunted-looking figure of Mrs Newton, but it is also a marvellously evocative image of domestic life in the late Victorian age. Similar in mood are the charming *Reading a Story* (116), *In the Sunshine* (86), which also evoke the mood of hot, lazy afternoons in an English garden, and *Hide and Seek* (117) which captures equally well the atmosphere of indoors rather than the garden. In a delightfully cluttered room, full of leather chairs covered with furs and rugs, Mrs Newton sits idly reading a newspaper, with a picture on an easel beside her. From behind a screen and a chair pop up three children's heads, while in the foreground a delightfully chubby and over-dressed blonde girl crawls across the carpet. Perhaps no picture conjures up the mood of domestic life in Grove End Road quite so well as this.

Another reason why Tissot exhibited so little during 1880 and 1881 was that he was preparing for a one-man exhibition, his first in England, which finally took place in May 1882 at the less well-known Dudley Gallery. The exhibition contained only eight paintings, but also his entire output of etchings in London, and twenty-one pieces of *cloisonné* enamel, a medium with which he experimented a good deal in the 1870s and 80s. The centrepiece of the show was the set of four large pictures, *The Prodigal Son in Modern Life* (118–121). Tissot had treated the theme of the prodigal much

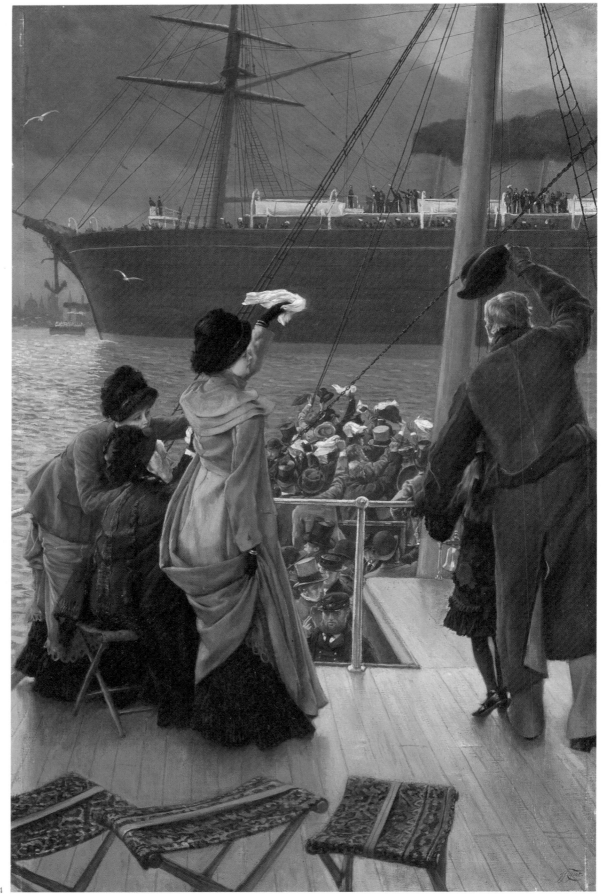

115 *Quiet*, c1881.

114 *Goodbye, on the Mersey*, c1881.

earlier in his career, but this set represents an entirely different approach. They are also of tremendous interest as the only religious pictures of Tissot's London period. The settings are at once familiar. In *The Departure* (118) the son takes leave of his father in a room overlooking a river, very similar to the background in *An Interesting Story*, painted nearly ten years earlier. Mrs Newton makes an inevitable appearance, seated demurely by the tea-tray sewing. The second scene, *In Foreign Climes* (119), is set in a Japanese tea-house, and is probably based on photographs. The errant hero is seen sitting to the right, in a smart suit and bowler hat, looking for all the world like a Victorian tourist. As an evocation of Japanese life, it has precisely the same period flavour as Puccini's *Madame Butterfly*. In the third scene, *The Return* (120), we are back on familiar territory once again, watching a shipboard drama in the London docks. A hint of the prodigal's former degradation is suggested by the pigs driven off to the left, while Mrs Newton looks on in elegant astonishment and a fur coat at the reconciliation of father and son.

The final scene, *The Fatted Calf* (121) shows the prodigal back in the comfortable bosom of his family. Our hero steps from a rowing-boat on the Thames (though wearing what looks like an I Zingari cricket cap) to join his family at lunch in a summer-house. Mrs Newton sits at the table, which is laden with an impressive silver cover no doubt concealing a large joint of roast beef. Our old friend the black and white dog also makes his appearance, sitting faithfully beside the lady of the house.

In spite of the familiarity of many of the settings and characters, in the Prodigal Son series Tissot created something strikingly new, and the pictures enjoyed a justifiable success at the time. A set of etchings was made from them, and Tissot later sent them to several international exhibitions, clearly considering them to be among his best and most serious works. As a moral parable they may seem to the modern viewer almost laughably innocuous, and certainly they cannot compare with the savage realism and bawdy humour of Hogarth's *The Rake's Progress*. Their true Victorian counterparts are the two moral progress series painted by Frith, *The Road to Ruin* and *The Race for Wealth*. In the first, a young man is led astray by the demon of gambling, ruining his family and finally being driven to suicide. In the second, we follow the career of a corrupt financier, at first successful,

116 *Reading a Story*, c1878–9.

117 *Hide and Seek*, c1880–2.

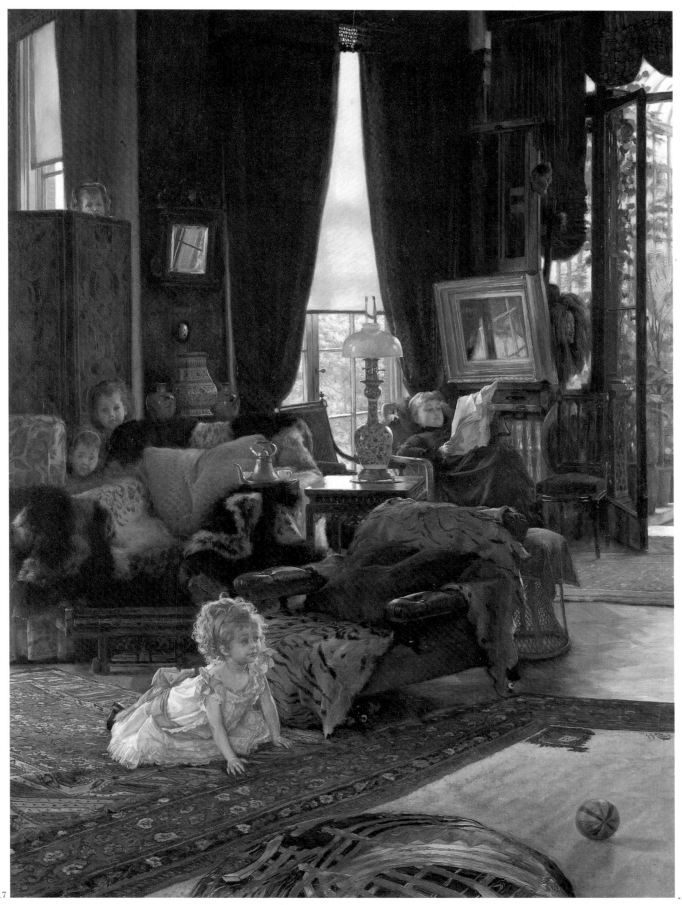

117

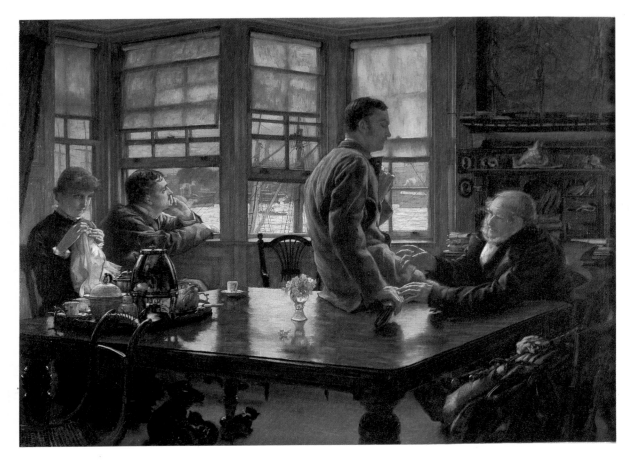

118 *The Prodigal Son in Modern Life:*
The Departure (*L'Enfant prodigue:*
Le Départ), c1882.

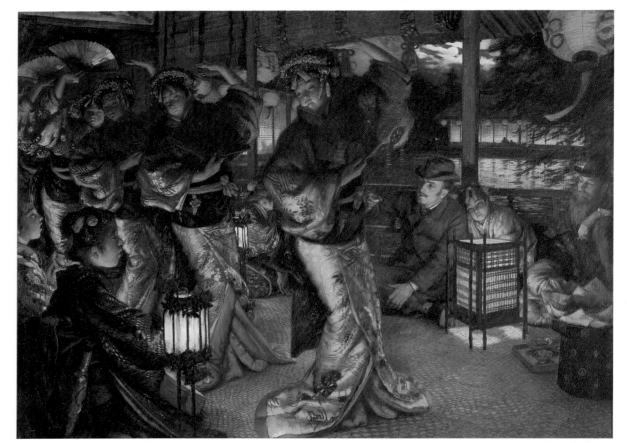

119 *The Prodigal Son in Modern Life:*
In Foreign Climes (*En pays*
étranger), c1882.

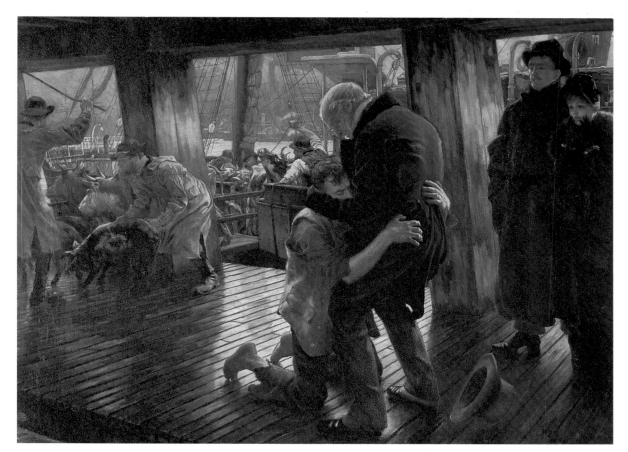

120 *The Prodigal Son in Modern Life:*
The Return (*Le Retour*), c1882.

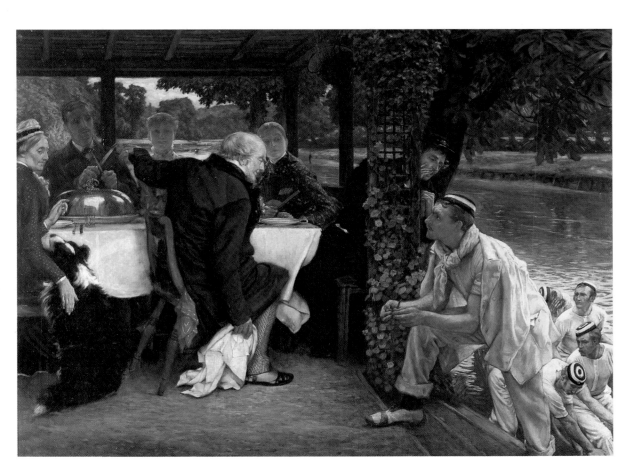

121 *The Prodigal Son in Modern Life:*
The Fatted Calf (*Le veau gras*), c1882.

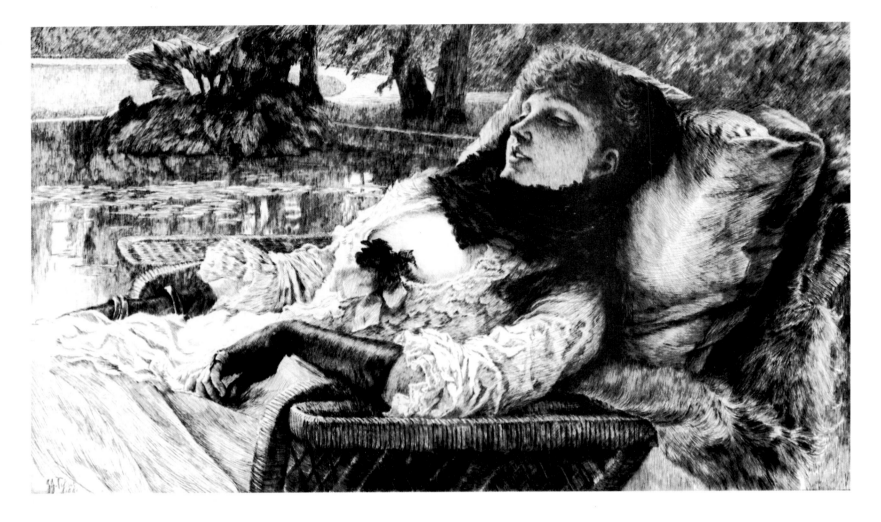

later on trial at the Old Bailey and finally imprisoned in Millbank Gaol. To us these Victorian moral progresses may seem absurdly earnest and prim, but we should not underestimate their effect on the Victorian public. The Victorians believed in original sin and the need to control it with discipline and muscular Christianity. To them, the modern parables of Tissot and Frith might have meant just as much as *The Rake's Progress* did to an eighteenth-century audience. Tissot himself may well have identified with the prodigal son, and his own return to the fold of the Catholic church was not far off. Frith, however, who also kept a lady and a second family in St John's Wood, seems to have suffered no such qualms. After his wife's death he married his mistress, and finally achieved the impressive total of nineteen children by the two wives.

The reception of Tissot's exhibition at the Dudley Gallery was in general cool. Although the *Illustrated London News* praised 'the taste in the arrangements', the critics either ignored the exhibition, or damned it with faint praise. Tissot later admitted to one of his biographers Alfred de Lostalot, that the English were beginning to resent not only his own success, but also the gradual invasion of English art by French ideas and influence.

During 1882, however, Tissot had other things on his mind. Kathleen Newton's illness was growing worse, and his later pictures of her, such as *Summer Evening* (122) clearly show that she did not have long to live.

122 *Summer Evening (Soirée d'eté)*, 1882.

123 Photograph of Tissot and Kathleen Newton on a garden bench.

124 *Renée Mauperin: Renée and her Father in the Porch of the Church at Morimond*, 1882.

125 *Woman Fainting (Renée Mauperin)*, c1881–2.

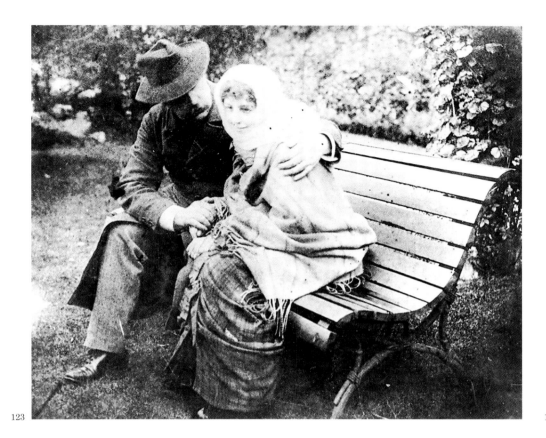

123

124

125

During the summer of 1882 he was commissioned by Edmond de Goncourt to illustrate his novel *Renée Mauperin*. He produced for the book a set of ten etchings, all of which were based on photographs, and in all of which Mrs Newton is depicted as the heroine. One of the most touching of them, *Renée and her Father in the Porch of the Church at Morimond* (124) is directly based on a photograph of Tissot himself and a clearly very ill Mrs Newton seated on a garden bench (123). Another, of which Tissot made a version in oil (125), shows Renée Mauperin fainting after hearing of her brother's death. It ominously foreshadows Mrs Newton's own death, which finally occurred in the winter of that year.

On 9 November 1882 she died of consumption at the age of only twenty-eight, and was buried in Kensal Green Cemetery. While the coffin stood in Grove End Road draped in purple velvet, Tissot prayed beside it for hours, overcome with grief. Finding the thought of life in London intolerable without her, he decided to leave at once. Within only five days he abandoned the house, leaving his paints, brushes and some unfinished canvases behind him, and fled to Paris. Later he sold the house to his friend Lawrence Alma-Tadema.

126 *The Garden Bench* (*Le Banc de jardin*), c1882.

127 *A Little Nimrod* (*Le Petit Nimrod*), c1882.

After his return to Paris, Tissot completed a large picture of Mrs Newton which he may have begun before her death. Entitled *The Garden Bench* (126) it shows Mrs Newton with Cecil George, Violet and Lilian, sitting in full sunlight in a summer garden on a bench draped with the fur rug already seen in *Quiet*. The picture obviously meant a great deal to Tissot because although he exhibited it in Paris the next year, he never sold it and kept it until his death. He also painted an enchanting companion picture, *A Little Nimrod* (127), of the children playing in a garden. For him, perhaps, both pictures represented a nostalgic memory of happy hours in the garden at Grove End Road, a recollection of a chapter in his life now for ever closed.

PARIS
1882-1885

The Painter of Parisian Life

And so, after an absence of eleven years, Tissot resumed his career as a Parisian artist. Outwardly, the motives for this sudden reversal of direction appear to be simply emotional. The death of Mrs Newton affected him deeply, and even Edmond de Goncourt, normally sceptical about anything to do with Tissot, was impressed by his genuine distress. 'A visit today from Tissot,' he noted, 'just arrived in the night from England – and who told me during our talk that he was much affected by the death of the English *Mauperin*, who, though already ailing, served as the model for the illustrations in my book.' In reality, however, Tissot's reasons for leaving England so suddenly may have been more complex. In spite of his considerable success, the English art world had been growing steadily more critical of his work, and in addition the enforced isolation of his relationship with Mrs Newton may have proved a considerable strain after nearly seven years. But whatever Tissot's reasons for leaving may have been, there is no doubt that had he wished to he could have stayed on in England and continued his career as a popular and prosperous artist. But evidently stronger forces were at work which impelled him to return to his own country and his own people.

128

The Political Lady (*L'Ambitieuse*), 1883–5.

129 *The Newspaper* (*Le Journal*), 1883.

130 *Sunday Morning* (*Le Dimanche Matin*), 1883.

Once back in Paris, he started to re-establish his life and reputation as quickly as possible. He moved back into his old house in the avenue de l'Impératrice, and immediately began to arrange a large exhibition of his work, to bring himself back into public notice and to show the critics what he had achieved over the past eleven years. This took place very soon after his return, in March 1883, at the Palais de l'Industrie, and contained an impressive total of 102 works. Most of these were from his English period, although Tissot changed their titles into French, which has caused endless confusion ever since. *London Visitors* was changed into *Au Musée de Londres*, and *Goodbye, on the Mersey* became *Le Départ d'un Cunard*. The *Prodigal Son* set was once again the centrepiece, as at the Dudley Gallery; and the exhibition also contained almost all his etchings and *cloisonné* work. In spite of this, it met with only a lukewarm response from the Parisian public. The English works were not admired, and one critic described Tissot

as 'a Parisian of London now become a Londoner of Paris'. To Parisian eyes Tissot's work had clearly become too English for their taste.

The one section of the exhibition that was admired was the pastels. This was not a medium that Tissot had used before, but after his return to Paris he used it continually, especially for portraits and portrait studies. The revival of interest in the art of the eighteenth century was reaching its peak during the 1880s, and this gave added impetus to the revival of pastel: once again Tissot was doing the right thing at the right moment. The only one of his pastels exhibited at the Palais de l'Industrie which is now identifiable is *The Newspaper*, a marvel of Parisian chic. Tissot made an etching of it, as he did with many of his pastels (129).

Throughout the 1880s and 90s Tissot was to continue to use pastel as his chosen medium. The Society of French Pastellists was founded in 1885, and Tissot joined soon after. Among its members were Puvis de Chavannes, Jean Raffaëlli, Jean Béraud, Madeleine Lemaire and Léon Lhermitte, but significantly two of the most outstanding users of pastel were not members: Degas and Odilon Redon. Manet, like Tissot, also used pastel for portrait studies of Parisian ladies.

Tissot's pastels are impressively stylish and inventive, and present a wonderful picture of Parisian society at this period. Their mood varies from the pensive simplicity of *Berthe* (132) to the more fraught emotional tension of *A Woman with a Gun* (131). Occasionally Tissot used pastel on a larger

131 *A Woman with a Gun*, c1895.

132 *Berthe*, 1883.

133 *The Princesse de Broglie, c*1895.

scale, as in the extraordinary *Princesse de Broglie* (133) of about 1895. The casual pose of the Princess, settling her ample and shapely hips on a circular table against a background of potted palms, is a strikingly provocative image. One could hardly wish for a better visual document of that dazzling and decadent Parisian society so beautifully and minutely described by Proust. The brilliant, almost virulent, greens of the de Broglie portrait are typical of Tissot's use of pastel. Such colours seemed to appeal to the showy tastes of Tissot's clients, but they did not appeal to de Goncourt, who described them as 'chilblain pink and ... leaden violet,' expressing only 'exhaustion, bewilderment, nausea ...' He was, however, comparing French nineteenth-century pastellists unfavourably with their eighteenth-century predecessors, such as Perronneau and Quentin de la Tour. From our standpoint the pastels of Tissot, Helleu and J.E. Blanche are just as representative of their age as those of the eighteenth century. Their real difference is one of period, not of artistic quality.

Tissot threw himself once again into Parisian society, haunting the clubs, restaurants and salons, but always rising early in the morning to go to Mass. He renewed old friendships, in particular with Boldini, Helleu and Forain, and he also attempted one or two romantic affairs, but with conspicuous lack of success. These are recorded in 1885, inevitably by Edmond de Goncourt, a cynical and waspish observer at the best of times. One of the objects of Tissot's emotions was a tightrope dancer, shown in pink in *The Acrobat* (137). He had to compete for her favours with a certain Aurélian Scholl, from whom de Goncourt heard his report. 'He described him for us – the old romantic [Tissot] accompanying his charmer to the station, holding the hoop through which she jumps in the one hand and the sewing machine with which she fixes up her costume in the other.' Clearly Tissot's affairs were providing his friends with a good deal of amusement. His other affair was with a certain Mlle Riesener, daughter of the painter Léon Riesener, and already, according to de Goncourt, 'a lady of a certain age'. She and Tissot became engaged, and Tissot even added an extra floor to his house in anticipation of the marriage. But then, according to the ever-malicious de Goncourt, the sight of Tissot's by now portly figure as he removed his overcoat decided Mlle Riesener to terminate the engagement. It can be no coincidence that soon after these disappointments Tissot began to dabble in spiritualist seances, in an attempt to conjure up the spirit of his lost love, Kathleen Newton. Tissot was to remain a bachelor for the rest of his life, though a rather wicked etching by Helleu of Tissot at the salon of the Princess de Polignac suggests that he remained susceptible to feminine charms (134).

Following his return to Paris and the rather disappointing reception of his exhibition at the Palais de l'Industrie, Tissot must have decided to make an impact on the Parisian scene with a new, large series of pictures. He chose as his theme the life of the women of Paris, and the result was the celebrated series of fifteen large pictures known as *La Femme à Paris*. These were first exhibited at the Galerie Sedelmeyer in Paris, and then at the Arthur Tooth Gallery in London in 1886. The idea of a set or series of pictures was probably an extension of the *Prodigal Son* series, but *La Femme à Paris* was a much more ambitious scheme, and the pictures do not form any logical sequence. Each simply depicts different types and classes of Parisian

134 Paul Helleu (1859–1972) *Tissot conversing with three women* (*Tissot causant avec trois dames*), c1893–4.

129

women engaged in their daily occupations. They clearly show Tissot responding bravely to the challenge of new directions in French art, and attempting to come to terms with them. During the 1880s the frantic bustle of Parisian life had become a dominant theme for French artists, and its most potent image was that fabled creature *la Parisienne*, a byword for sauciness and elegance throughout Europe. Although *la Parisienne* was as much a creation of writers and journalists as the modern Sloane Ranger, she inspired so many artists of the day that she cannot simply be dismissed as a fashionable invention. Tissot's great series does convey a wonderful feeling of the intense excitement and variety of Parisian life in the 1880s; *la Parisienne* is the heroine, but Paris itself is the hero.

The first thing to be said about the Paris series is that they are much larger in scale than anything Tissot had attempted before. He obviously hoped to make more impact by working on a monumental scale, and it is a development which is paralleled in the careers of many of his contemporaries, including Manet, Seurat and Degas. The other change is in his technique, which becomes progressively looser and more impressionistic. This change had already begun in London, and is evident in the large *Garden Bench* (126) completed soon after his return to Paris. Instead of the smooth finish of the 1870s, the Paris series are painted with dense patterns of visible brushwork, in a lighter range of colours, giving the pictures a much heavier impasto when looked at closely. As usual, Tissot was trying to reconcile Impressionism and conservatism, steering his own very individual middle course between the two.

Although the last of the Paris series, *Sacred Music*, is lost and may never have been completed, the remaining fourteen are all known either in the original or through photographs, although in some cases only replicas or etched versions survive. But as Tissot's last and most ambitious attempt at a survey of modern Parisian life, they are worth examining in detail. Paris in the late nineteenth century was the era of the courtesan, *la grande horizontale* as she is often called. Many of them enjoyed spectacular careers, amassing comfortable fortunes that must have been the envy of respectable wives. Many of Tissot's ladies in the Paris series are clearly courtesans, shown in the company of rich old men.

First comes *The Political Lady* (*L'Ambitieuse*), shown arriving at an evening party or dance on the arm of her elderly admirer (128). This composition was almost a direct reworking of a picture entitled *Evening*, which Tissot had exhibited at the Grosvenor Gallery in 1878. *Evening* was a portrait of Kathleen Newton, but in *L'Ambitieuse* he used a different model and changed the colour of the dress from yellow to pink. Unfortunately this shade of pink aroused the scorn of the Paris critics, one of whom wrote, 'Tissot has an unfortunate and dated passion for poppy pink; he loves this shade of red; he sticks it in everywhere; corsages, horses, the trains of dresses. He takes it for the height of elegance.' Clearly to the trained Parisian eye Tissot's ladies were beginning to look a little out of date. But whether Tissot is depicting the fashions of the 1870s or the 1880s is hardly likely to worry the present-day viewer, who can simply enjoy *L'Ambitieuse* as a brilliant and daring composition. The woman walking away from the spectator and looking back is one of Tissot's favourite tricks, and here succeeds felicitously. The atmosphere of a crowded salon is cleverly

135 *The Woman of Fashion* (*La Mondaine*), 1883–5.

suggested by the dense crowd of figures to the left, and the buzz of gossip is hinted at by the two men whispering to the right and the monocled figure to the left gazing at the new arrival with unconcealed admiration. The lady herself is certainly a wonderfully elegant figure, even if her frothy frills and pleats were by then sadly old-fashioned.

Much the same can be said of *The Woman of Fashion* (*La Mondaine*) which shows an elderly man helping a fashionable young lady into her cape on leaving the theatre (135). This time the main figure of the smart young girl stares directly out at us, as if to give the spectator a flirtatious glance.

Clearly the old gentleman is going to have his work cut out holding on to this flighty young mistress. Again the composition, with the staircase descending to the left, is brilliantly arresting, as are the patterns of the carpet and floor tiles. In the faces of the figures, however, one can detect those faint elements of caricature, bordering on the grotesque, which were to strike many critics of the series.

These defects are even more noticeable in *The Fashionable Beauty* (*La Plus Jolie Femme de Paris*), showing a strangely doll-like young lady passing through a doorway between an avenue of gentleman admirers (136). Here the distortions and elongations of the figures give the picture a tense, almost hysterical, quality. The faces of several of the men become alarmingly close to caricature, and the lady's back view in the foreground looks distinctly uncomfortable. One senses that Tissot was here striving for effects somewhat beyond his powers.

Among the many attractions of Paris, apart from her grand courtesans, were her dancers, actresses, circus performers, waitresses, shopgirls, *grisettes* of all kinds, famed for beauty, charm and gaiety. Tissot has depicted several of this breed from the *demi-monde* in his series, notably in *The Ladies of the Cars* (*Les Dames des Chars*) and *The Acrobat* (*L'Acrobate*) depicting lady circus performers (138) (137). These are two of the most successful of the series. *Les Dames des Chars* is set at the Hippodrome de l'Alma, and shows a parade of female performers in their horse-drawn chariots. As in his earlier pictures of horses, such as *Going to Business* (110), Tissot has brilliantly suggested the sense of movement by the daringly close-up view of the first horse and its chariot, and by abruptly cutting off one of the second pair of horses. Above us tower the Amazonian figures of the circus girls, in their glittering chain-mail costumes and head-dresses reminiscent of the Statue of Liberty. Above them hang the globes of the electric lights, at that time a glamorously new invention, surmounted by the splendid cast-iron construction of the Hippodrome itself. The audience is seen only as a sea of faces in the background. This surely is one of the most exciting of all pictures of circus life in the nineteenth century. Equally good is *The Acrobat*, balancing on her tightrope in a pink leotard draped with imitation flowers, while a sea of top-hatted and bewhiskered gentlemen gaze longingly at her from below. This, of course, is the tightrope dancer unsuccessfully pursued by Tissot, but at least she was responsible for one of the better pictures in the series.

Affairs with circus girls became almost a fashionable craze in the 1880s and 90s. In Huysmans' decadent novel *A Rebours*, for example, the hero des Esseintes for a time enjoys the embraces of a muscular female acrobat. Tissot included yet another circus scene in the set, *The Sporting Ladies* (*Les Femmes de Sport*) (139). This shows one of the smaller, fashionable circus-rings where members of Paris society could go and themselves perform as clowns, acrobats and tightrope artists. Here the viewpoint is taken from amongst the audience, one of whom, an elegant lady with a fan, turns to cast a cool glance at the spectator. In the ring is a clown, while overhead two elegant male performers sit on trapezes, one still sporting his monocle. Tissot was criticized for including too many circus pictures, giving the impression that Parisians spent most of their time there. One critic sarcastically described *The Acrobat* as 'completing this series of manifestations of the elegant life of a Parisian lady'.

136 *The Fashionable Beauty*
(*La Plus Jolie Femme de Paris*), 1883–5.

138 *The Ladies of the Cars*
(*Les Dames des Chars*), 1883–5.

137 *The Acrobat* (*L'Acrobate*), 1883–5.

Of the many possibilities offered by working girls, Tissot chose only one other, *The Shop Girl* (*La Demoiselle de Magasin*) (140). Here again the viewpoint is extremely striking: seen from inside the shop, the girl holds the door open for the invisible customer to depart. Beyond is the bustle of a Paris street, a footman with two horses, with only their noses visible, and a man leering through the window at another shop girl taking something off a shelf. Once again Tissot cleverly leads the spectator into the picture, forcing his psychological participation in the scene depicted.

The occupations of fashionable ladies take up most of the remainder of

139 *The Sporting Ladies* (*Les Femmes de Sport*), 1883–5.

140 *The Shop Girl* (*La Demoiselle de Magasin*), 1883–5.

the series, but several of these are lost. *The Mysterious Lady* (*La Mys-térieuse*) is now only known through a small oil sketch (143). The subject seems to have been suggested by a passage in one of Ouida's best novels, *Moths*, describing the mysterious Anglo-Russian Princesse Zouroff walking in the Bois de Boulogne; 'she was in black, with some old white laces about her throat; before her were her dogs, and behind her was a Russian servant.' There is little of the mysterious, however, about Tissot's elegant mannequin with her cool stare. Here his inventiveness failed him, although it remains an elegant if rather superficial picture. Once again the figures are curiously elongated, an impression increased by the vertical lines of the trees either side.

Similarly lacking in narrative bite are *The Liar* (*La Menteuse*) and *The Sphinx* (141) (142), both now lost. It is difficult to know quite what *The Liar* is lying about, unless it is the cost of the expensive parcels and flowers she is carrying. *The Sphinx* seems an unduly portentous title for a picture of a thoughtful lady sitting on a sofa. The only riddle seems to be who is the owner of the gentleman's hat and stick on the chair beside her. The main interest of both pictures would seem to lie in their wealth of period costume and interior detail.

141 *The Liar* (*La Menteuse*), 1883–5.

142 *The Sphinx*, 1883–5.

143 *The Mysterious Lady* (*La Mystérieuse*), 1883–5.

144 *The Provincial Ladies* (*Les Demoiselles de province*), 1883–5.

145 *The Artist's Ladies* (*Les Femmes d'artiste*), 1883–5.

141

142

143

145

144

The *Provincial Ladies* (*Les Demoiselles de province*) is also a lost picture (144). It seems to be a Parisian version of Tissot's earlier masterpiece *Too Early* (64), though with less happy results. *The Artist's Ladies* (*Les Femmes d'Artiste*) is more successful, and shows one of those lively café scenes so beloved of Béraud and his contemporaries in the 1880s (145). Tissot's picture is certainly a brilliant contribution to the genre, although the arch expression of the lady turning around to look at the spectator strikes a somewhat false note. More successful is the lady holding a chair to the right.

Without a Dowry (*Sans Dot*) (146), set in the gardens of the Tuileries,

146 *Without a Dowry* (*Sans Dot*), 1883–5.

147 *Letter 'L' with Hats*, *c*1885.

shows a recently bereaved but very pretty lady in black, with her mother reading the papers beside her. In the background are two soldiers, one of whom is clearly looking admiringly in her direction, but also keeping his distance. The subject of the picture, with its emphasis on forlorn widows and hopeless children left unprovided for, might well have struck the Parisian viewer as very Victorian. *The Bridesmaid* (*La Demoiselle d'Honneur*) shows a happier ending, as a bridegroom hands a bridesmaid to her carriage (149). The setting looks more like London than Paris, and here again the subject would have probably struck the Parisian viewer as typically English. One

149 *The Bridesmaid (La Demoiselle d'Honneur)*, 1883–5.

148 *The Traveller (La Voyageuse)*, 1883–5.

Paris reviewer parodied the picture as, 'The Prince of Wales, aged twenty, helps a young lady into a cab, rue Saint-Denis'.

The exhibition at the Galerie Sedelmeyer also included two other pictures intended for a second series devoted to foreign women, entitled *L'Etrangère*. Tissot completed only two of these, *The Traveller (La Voyageuse)* (148) and *In the Louvre (L'Esthétique)* (150). *The Traveller* seems to be a posthumous tribute to Mrs Newton, seen descending the steps of a ship in an immaculate outfit and veil. *In the Louvre* is a much more arresting composition, and is one of a group of studies Tissot made of figures in the

150

150 *In the Louvre (L'Esthetique)*, 1883–5.

151 *Foreign Visitors in the Louvre*, c1880.

Louvre (151). The placing of the urn and pedestal in the foreground is a clever device, although it inevitably makes the copyist on the left look rather cramped. The lady, as befits an artistic type, is wearing a very English-looking aesthetic dress. The model again resembles Mrs Newton, but both this picture and *The Traveller* must have been painted after her death.

Tissot planned to produce etched sets of the whole series, accompanied by short stories appropriate to each picture written by leading authors of the day, including Zola, Maupassant and Alphonse Daudet. Regrettably only five of the etchings were ever produced, and neither these nor any of the short stories were issued. The reason was twofold; firstly, Tissot was by 1886 turning his energies towards his Bible illustrations; secondly, the *Femme à Paris* series was not a success. Both in Paris and London, its reception had been extremely discouraging. The French critics on the whole dismissed the series as too English: the critic of *La Vie Parisienne* wrote, 'There is no question of *la Parisienne* here; the painter has simply given us a series of fourteen more or less successful examples of English life wherein a barmaid was his sole model throughout. One could take them for enlarged, coloured caricatures from *Punch*.' Tissot's return to Paris was to be dogged by this unfair and very chauvinistic attitude. The same critic went on to complain, 'to give this series of canvases an even more English air, the painter has had them put under glass. One cannot tell whether they be oil, watercolour, pastel or oleography.'

Ironically, the *Femme à Paris* pictures have remained more popular with English and American collectors than with the French themselves. It is no accident that of all the pictures so far located, not one remains in France. It is not easy for us, after a hundred years, to fathom why this remarkable set of pictures made so little appeal to Tissot's contemporaries. Many great French artists were painting modern-life subjects in the 1880s, including Renoir, Degas and Manet, but although their choice of subjects might be similar to those of Tissot, their treatment of them was so different that any direct comparison is impossible. In any case, all painters of modern life, be they Impressionists or academics, risked accusations of vulgarity, banality and ugliness. What clearly did not appeal to Parisian taste was Tissot's strongly realistic narrative style, which must have seemed too literal and unimaginative. His rooted insistence on narrative content and period detail must have seemed more English and Victorian than truly Parisian. And certainly the inspiration of the whole series is fundamentally literary. Tissot's friend and neighbour, Alphonse Daudet, probably played a larger role than we know in the formation of the series. He was to write a story to accompany the picture *La Menteuse*, and it was probably he who approached all the other writers for contributions. The inspiration behind the series was, therefore, largely literary, and perhaps dictated Tissot's choice of subjects. This may explain why they are such an odd mixture.

But all these considerations were shortly to become irrelevant for Tissot himself. In 1885, his career was to take its final, extraordinary change of direction. The painter of society was to become the painter of the Bible.

PARIS
1885-1902

The Painter of the Bible

Tissot's dramatic conversion, or re-conversion, to the Catholic faith took place in 1885, while he was working on the last of the *Femme à Paris* series. Entitled *Sacred Music*, it showed a young woman singing with a nun in the organ-loft of a church. Tissot went in search of inspiration for this picture to the church of S. Sulpice in Paris. Here, during Mass, he experienced the vision that was to change his life. Tissot later described the event himself:

> . . . As the Host was elevated and I bowed my head and closed my eyes, I saw a strange and thrilling picture. It seemed to me that I was looking at the ruins of a modern castle . . . then a peasant and his wife picked their way over the littered ground; wearily he threw the bundle that contained their all, and the woman seated herself on a fallen pillar, burying her face in her hands . . . And then there came a strange figure gliding towards these human ruins over the broken remnants of the castle. Its feet and hands were pierced and bleeding, its head was wreathed in thorns . . . And this figure, needing no name, seated itself by the man, and leaned its head upon his shoulder, seeming to say . . . 'See, I have been more miserable than you; I am the solution to all your problems; without me civilization is a ruin'.

152
*Portrait of the Pilgrim, c*1886–94.

Tissot painted a picture of this vision, entitled *The Ruins*, or *Inner Voices* (153) which is now lost, and known only through engravings. It is a particularly ghastly example of the effects of nineteenth-century religiosity on art, but in the context of Tissot's career it is nevertheless a fascinating document. The setting seems to be not so much a castle as Paris devastated after the Commune risings. To one accustomed to the elegant clutter of Tissot's interiors, the foreground rubble comes as a peculiar visual shock. The peasants are not very convincing, but the figure of Christ, a Svengali-like apparition covered with blood, ominously foreshadows the future direction of Tissot's art. For after this vision, Tissot decided to devote the rest of his life to illustrating the Bible. Ironically, the Tissot Bible was to bring him greater riches and fame than he had ever known as a painter of modern life.

Tissot's friends and fellow-artists, in particular Degas and de Goncourt, remained consistently sceptical about Tissot's conversion. They chuckled to themselves that the incorrigible old adventurer had now got religion, and was making a good thing out of it. It is certainly difficult to counter the charge that Tissot's conversion was as much opportunist as religious. It was both an emotional change and a professional one. But it needs to be seen against the background of the Catholic revival, which was a notable feature of French life during the last quarter of the century.

The Catholic revival was essentially a reaction against the anti-clerical and secular spirit of the Third Republic. The church, and the more conservative classes of society, saw the Catholic religion threatened. Combined with this was a distrust of rational and scientific developments, which undermined the very basis of faith. As a result, the Catholic reaction took on a highly hysterical flavour, with a strong tendency towards piety of a peculiarly intense and mystical kind. Their answer to the twin threats of secularism and science was to soar above them into the hazy realms of divine revelation. Miraculous visions gained immense publicity and popularity, and the kind of fashionable conversion which Tissot experienced was very common at the time. The visionary writings of Anna Katherine Emmerick had a tremendous influence on the movement, and Tissot acknowledged his debt to her in his preface to the New Testament illustrations. The passions and tensions between church and state engendered by the Catholic revival finally erupted in the extraordinary Dreyfus trials of the 1890s, which split French society from top to bottom, and nearly caused civil war.

Artistically speaking, the effects of the Catholic revival were not happy. In fact, two of its chief manifestations are the Tissot Bible and the church of the Sacré Coeur in Paris. Another particularly remarkable example is Jean Béraud's picture *Saint Mary Magdalen Prostrate before Christ in the House of the Pharisee* (154), in which Jesus makes his appearance at a Parisian dinner party. Liane de Pougny, a famous courtesan of the day, prostrates herself, as Mary Magdalen, at Jesus' feet. Around the table are seated various figures particularly hated by the Catholic revival: Ernest Renan, author of the sceptical *Life of Jesus*; Chevreul the scientist; Dumas the younger; and Clemenceau himself, President of the dreaded Third Republic. This quite extraordinary picture gives an excellent idea of the passions aroused by the religious debates of the period, and an insight into the nature of the Catholic revival itself. As Michael Wentworth has neatly put it, Jesus was the man who came to dinner in the 1890s.

153 *The Ruins* (*Inner Voices*), 1885.

154 Jean Béraud, *Saint Mary Magdalen Prostrate before Christ in the House of the Pharisee*, 1891.

Hand-in-hand with Tissot's new-found Catholic faith went his absorption in spiritualism, another phenomenon of the age. The immense popularity of spiritualism in the late nineteenth century is traceable to the same roots as the Catholic revival. Spiritualism provided an alternative to religious doubt. It gave a pseudo-scientific answer to the problems of the after life, by conjuring up the spirits, and the physical presence, of the dead. The role of the medium was vital, and this spawned a whole generation of immensely successful spiritualist adventurers, most of whom simply exploited the vogue by means of trickery and fraud. Séances, complete with table-turning, spirit-rapping and the raising of the dead, were the order of the day, and gained an immense following among perfectly intelligent and sincere people. Spiritualism was simply an expression of the nineteenth century's intense desire to believe – the other side of the coin of orthodox religious faith.

Tissot met William Eglinton in Paris in 1885, and through him was introduced to spiritualism. Eglinton was one of the most successful mediums of his day, and practised successfully in Europe and throughout the world.

The story of his life is told in a biography by John S. Farmer entitled *'Twixt Two Worlds: A Narrative of the Life and Work of William Eglinton*, published by the aptly named Psychological Press in 1886. The frontispiece of the book is a portrait of Eglinton by Tissot (155). Eglinton specialized in the materialization of spirits and slate-writing, a method by which the dead supposedly left messages on a slate, which encouraged highly inventive trickery of all sorts. Tissot was so impressed by Eglinton that he followed him to London, where he undertook a series of seances. At one of these, on 20 May 1885, he was convinced Mrs Newton appeared to him. The scene was faithfully recorded by Farmer:

> At the last and culminating seance he had a touching and unique experience. The veil was lifted, and he saw one whose sweet companionship had been his joy and solace in years gone by ... The seance, a private one, took place on the 20th May, and there were present, besides M. Tissot and the medium, three ladies and one gentleman ... The doors were all locked, and the room otherwise secured. After conversing for a time, two figures were seen standing side by side on M. Tissot's left hand ... The light carried by the male figure ('Ernest') was exceptionally bright, and was so used as to light up in a most effective manner the features of his companion. M. Tissot, looking into her face, immediately recognised the latter, and, much overcome, asked her to kiss him. This she did several times, the lips being observed to move. One of the sitters distinctly saw 'Ernest' place the light in such a position that while M. Tissot was gazing at the face of the female form, her features were 'brilliantly illuminated'; it also lighted M. Tissot's face. After staying with him for some minutes, she again kissed him, shook hands, and vanished.

Another, earlier, seance was recorded by the painter Jacques Emile Blanche, who was thoroughly sceptical about the whole business. This seance took place at the studio of the painter Albert Besnard in London, and Mrs Newton once again appeared before Tissot. This time, however, the spirit form turned out to be a model used by Besnard, and the medium was jailed for fraud. Tissot, however, was undeterred, and made a painting of the apparition that had appeared to him at the Eglinton seance. This was eventually produced in mezzotint, entitled *The Mediumistic Apparition* (156), and was reproduced in Farmer's book. The painting is now lost, unfortunately, as it is certainly fascinating both as a Tissot and as one of the few records of nineteenth-century spiritualism. Tissot kept the picture in a special room in his house reserved for spiritualist seances of his own. De Goncourt saw it when he visited Tissot one afternoon in 1890 with Alphonse Daudet and his wife, to see the progress of the Bible illustrations.

> We went upstairs for a moment to see how he had arranged the interior of the upper floor he had built when he thought he might marry Mlle Riesener ... And then in the twilight, refusing to fetch matches, he showed us – with hushed mysterious voice and staring eyes, the crystal ball and enamel saucer which serve his seances, during which he assures us one hears voices in argument. He brought notebooks out of a drawer, in which he showed us entire pages containing the accounts of these

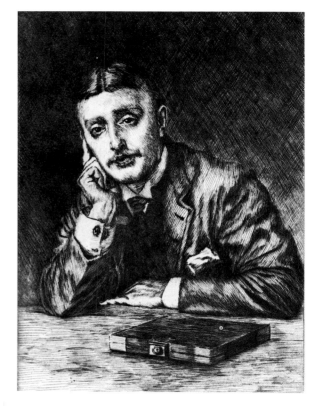

155 *William Eglinton*, 1885.

156 *The Mediumistic Apparition* (*L'Apparition médiumnique*), 1885.

raisings of spirits, and then finally he showed us a painting representing a woman with luminous hands, whom he said came to kiss him and whose lips he felt on his cheek and lips, lips as of flame.

De Goncourt does not directly say so, but his sarcastic tone clearly indicates that he found the whole performance both ridiculous and tiresome.

This strange atmosphere of Catholicism and spiritualism provides the background for what was to be the last great project of Tissot's artistic career. This was to be nothing less than the illustration of the whole of the Bible. The first stage was the New Testament, on which he laboured for eight years, from 1886 to 1894, producing a total of 365 illustrations. Like the Pre-Raphaelite painter William Holman Hunt had done before him, Tissot travelled to the Holy Land in search of exact historical locations and period details. His first trip to Palestine took place soon after his vision in S. Sulpice, from October 1885 to March 1886. He was to make two further trips in 1889 and 1896. This documentary approach was typical of the spirit of the age. In keeping with their rational and scientific spirit, the Victorians wanted to explore the precise historical basis for the life of Jesus. As Tissot pointed out in his introduction to his *Life of Jesus*, 'all schools of art have worked ... to lead astray public opinion in these matters ... Is it not time in this exact century ... to restore to reality – I do not say to realism – the rights which have been filched from it?' As a result, Tissot's Bible is much more than an illustrated New Testament; it is a kind of Catholic Baedeker, explaining not only the exact sites of Biblical events, but correct costumes and hairstyles, and even the right number of wings on the cherubim. In this respect, Tissot's approach is precisely the same as other artist-antiquarians of the nineteenth century.

During his first stay in Palestine, Tissot set about accumulating a vast file of documentary evidence in the shape of drawings, sketches, notes and photographs. Unfortunately his photographic files no longer survive, but they doubtless resembled similar collections made by other nineteenth-century artists. Alma-Tadema, for example, had a vast personal collection of photographs relating to Roman life and architecture, which eventually filled over seventy volumes. Like Alma-Tadema, Tissot was to draw on his files for the rest of his career, incorporating them as he needed into his illustrations. A later magazine article described his working day: at six in the morning he attended Mass at the Convent of Marie-Réparatrice; afterwards he went out sketching for most of the day; and evenings were devoted to religious contemplation, research and making preparatory sketches. Just as Holman Hunt had done, he sought local models for the main figures in his illustrations, to give them an added air of authenticity. The figure of Pontius Pilate was taken from a Roman bust; but the subsidiary figures were mostly modelled from Parisian waiters. In spite of the immense amount of labour involved, and the vast accumulation of material, Tissot's Bible can lay no claim to either historical or archaeological accuracy today. His approach was too personal and too indiscriminate, and in historical terms his Bible is therefore nothing more than a dated period piece.

Once back in Paris, Tissot set about transposing his material into actual pictures. Here personal and imaginative factors came into play. As Tissot

wrote in his own introduction, 'The general data put me on the right track for the studies I had to pursue. All that was needed now was intuition'. Unfortunately Tissot began to confuse artistic intuition with divine revelation, and it becomes increasingly difficult to take him seriously after this point. The self-righteous and solemn tone of Tissot's introduction to the New Testament makes embarrassing reading today. Although he denied that his approach was at all mystical, this is precisely what it was. Following his experiences in the Holy Land, he wrote that 'a certain receptivity was induced in my mind which so intensified my powers of intuition, that the scenes of the past rose up before my mental vision in a peculiar and striking manner.' He goes on to speak mysteriously of 'the brilliant light, almost amounting to divination, which was thrown on various points by the sight of certain stones ... ' In 1899, a long article was published in an American periodical, *McClure's Magazine*, by Cleveland Moffett, describing Tissot's work on the Bible illustrations. The article was intended to boost sales of the Bible in the U.S.A. and the tone is grindingly respectful and reverent. In it he sets forth Tissot's account of his working methods:

> M.Tissot, being now in a certain state of mind, and having some conception of what he wished to paint, would bend over the white paper with its smudged surface, and looking intently at the oval marked for the head of Jesus or some holy person, would see the whole picture there before him, the colors, the garments, the faces, everything that he needed and already half conceived. Then, closing his eyes in delight, he would murmur to himself 'How beautiful! Oh, that I may keep it! Oh, that I may not forget it.' Finally, putting forth his strongest effort to retain the vision, he would take brush and color and set it all down from memory as well as he could.

With dreadful smugness, Tissot also described to the gullible Moffett other visions that were never painted, 'because the very gorgeousness of the scene made it slip from him as a dream vanishes, and it would not come back. "Oh," he sighed, "the things I have seen in the life of Christ, but could not remember! They were too splendid to keep." ' In another passage he describes a further vision of Christ crowned with thorns, which appeared to him on a balcony in Paris near the Bois de Boulogne. Reading these distressing revelations, one realizes that Tissot's imagination had by this time strayed into realms of fantasy that it would be best not to pursue further. De Goncourt has left us a wonderful description of a visit to Tissot's studio in the 1880s:

> At our entrance, the worldly sounds of heaven from a harmonium played by the artist, then as he came towards us, our glance was abruptly drawn to an illuminated opening showing an unfinished watercolour. The opening [was] in some material, something like the curtain of a child's theatre in which little puppets are seen in a Passion scene, the whole lit like a Holy Sepulchre on Good Friday with a glow of reddish light.
>
> Then began the procession past the twenty-five gouaches, for which Tissot produced the patter in the hushed tones one uses in church, occasionally, however, dropping little explosions of Parisian slang into his pious talk, saying of the Magdalen, pictured as still a sinner in one study, 'You see, she is a little past it'.

157 *The Sojourn in Egypt, c1886–94.*

158 *The Journey of the Magi, c1886–95.*

Goncourt's reference to puppet figures on a miniature stage suggests that divine revelation was not the only thing Tissot used in creating his compositions. But none of this could detract from Tissot's eventual triumph when the illustrations were shown to the public. This exhibition, which consisted of 270 out of the eventual 350 pictures, took place in the spring of 1894 at the Salon du Champ-de-Mars. It was unquestionably the greatest public success of Tissot's career. The exhibition was filled every day by a wondering and reverent audience, the men respectfully removing their hats. Some women even sank to their knees, and literally crawled round the rooms in reverent adoration, sobbing and crying before particular scenes. For once, Tissot had found exactly what the public wanted. With their combination of mystical piety and pseudo-scientific accuracy, his illustrations captured exactly the religious mood of the day.

Following the Paris exhibition, the illustrations were shown in London in 1896, and again in Paris in 1897. In 1898 they toured America, raising over $100,000 in entrance fees, and were then acquired by the Brooklyn Museum for a further $60,000. The success of these exhibitions was followed by the publication of *The Life of our Lord Jesus Christ*, with 350 illustrations by

Tissot, first in France in 1896–7, and later in England and America. Tissot received one million francs in reproduction rights from the French publishers, and the book went through numerous editions until about 1910, making it familiar to a whole generation of Catholics. The first edition, in two volumes, was of extremely high quality, with silk bindings and wooden boxes, but later editions become steadily more inferior. Their success ensured that Tissot would be a rich man for the rest of his life.

It is, therefore, with some trepidation that the modern student approaches Tissot's actual illustrations. The medium of the whole set is gouache, a mixture of watercolour and body colour, on paper, and they are still preserved at the Brooklyn Museum in New York. At least two are also known to have been produced in oil – *The Sojourn in Egypt* (157) and *The Journey of the Magi* (158). It is in these purely narrative and topographical subjects that Tissot is at his best. Like so many artists of the nineteenth century, he was clearly entranced with the colourfully exotic life that he found in the Middle East. In the background of *The Sojourn in Egypt* one can even detect additional echoes of his shipboard scenes on the Thames. But when Tissot tries to convey visionary subjects in a strictly literal manner, the results can be quite extraordinary. *The Soul of the Penitent Thief in Paradise* (159), for example, shows the tiny figure of the thief being literally lifted by angels into orbit above the earth. The angels, whose faces remind one uncomfortably of the *Femme à Paris* series, are quite unconvincing, and the whole scene has more of a spiritualist apparition about it than a religious vision. This is one of the more striking of the visionary scenes; most of the rest, like *It is Finished* (160), become unbearably turgid.

The scenes most admired in Tissot's day were the scenes of the Passion, and here Tissot did succeed in creating some remarkable religious images. *Christ falls beneath the Cross* (161) is deliberately crude and violent. The low viewpoint draws the spectator into the scene, although the effect is weakened, as in so many of the Passion scenes, by the Svengali-like features of Christ. In his earnest attempt to give Christ's face an expression of spiritual suffering, Tissot only succeeded in producing another hypnotic spiritualist apparition. Similarly disastrous attempts can still be seen in Catholic churches and seminaries all over the world.

Perhaps the most remarkable of all the Passion scenes is the audacious *What Our Saviour saw from the Cross* (162) in which the feet of Christ actually appear at the bottom of the picture. This is the most striking of all the Passion scenes, in which the spectator is literally made to feel that it is he who is hanging from the cross. Although it may appear in dubious taste today, it was precisely this brand of vulgarity, realism and mysticism that appealed to the Catholic faithful of the 1890s. At the end of the book, Tissot produced a portrait of himself as *Portrait of the Pilgrim* (152) surrounded by Catholic and Jewish paraphernalia. Underneath is an exhortation to pray for the soul of the author. Looking at the devout figure of Tissot, now grey-haired and portly, it seems difficult to grasp that this is the same artist who painted fashionable society and *La Femme à Paris*. Of course the irony is that even while working on the Bible series he continued to produce pastel portraits of society ladies and courtesans.

The art world of Paris was thrown into turmoil by the success of Tissot's Bible. Clearly it became a talking-point in artistic circles. De Goncourt

159 *The Soul of the Penitent Thief in Paradise*, c1886–94.

160 *It is Finished*, c1886–94.

161 *Christ falls beneath the Cross, c1886–94.*

162 *What Our Saviour saw from the Cross, c1886–94.*

describes a heated discussion which took place at a dinner given by Alphonse Daudet in May 1894:

> ... battle ... raged over the series Tissot has painted of Christ by which Zola declared he had been captivated ... which Daudet assured us would have converted him if he were not such an imbecile; which Raffaëlli tore into as being a revolting injustice ... And when it had been agreed that the quality of the paintings was overall that of historical reconstruction, there were those who said that the history of Christ should be treated in a legendary style, without benefit of fidelity in setting or racial types, and those of us who upheld that the history of Christ was history ... and that Tissot's reconstruction was in keeping with the contemporary approach to history.

After this the discussion grew even more violent between Daudet and Raffaëlli. De Goncourt, despite being impressed by Tissot's success, was critical himself. He put his finger unerringly on the weakness of Tissot's Bible – the contrast between reality and fantasy.

> One thing that strikes me, that amazes me, about this devotee of the occult, this spiritualist, this raiser of phantoms, is that he only really succeeds in that which reflects his observations of reality, that he is not able to contrive that which is visionary; his depiction of apparitions and the supernatural is very mediocre; thus Jesus asleep surrounded by blue angels stretching out indigo hands with little flames at their foreheads look like nothing so much as a peacock's tail.

Ary Renan devoted a long article to the series in the *Gazette des Beaux-Arts*, praising its 'moral tone' and 'prosaic simplicity'. In his opinion it was worth the effort; 'For an understanding of the life of Christ this is a major step; in any case no one will deny that the portentous happening which changed the face of the world is worthy of the effort made towards such a literal reconstruction ... ' Perhaps the last word should go to the painter Maurice Denis, who wrote that 'The Christ of Byzantium is a symbol; the Christ of modern artists, even if clothed in the most authentic of *kiffeds*, is nothing more than mere literature.' This ultimately is the flaw in Tissot's Bible; in attempting to describe the life of Christ and its significance in purely literal and literary terms, he was really attempting the impossible. However, history may give him credit for an interesting attempt.

But there were those who could never forgive Tissot for his success or for his pompous religiosity. Among them was Degas, who wrote in a letter to his friend Halévy, 'Now he's got religion. He says he experiences inconceivable joy in his faith. At the same time he not only sells his own products high but sells his friends' pictures as well ... Well, I can take my vengeance. I shall do a caricature of Tissot with Christ behind him, whipping him, and call it *Christ driving His Merchant from the Temple*. My God!' The reference to 'friends' pictures' clearly refers to a picture which Degas had given to Tissot many years before, and which Tissot sold during the 1890s.

By this time Tissot was able to live on the princely scale of the successful nineteenth-century artist. He had inherited the Château de Buillon from his father in 1888, and thereafter divided his time between there and his house in Paris. A self-portrait of 1898 shows Tissot looking more the country squire

163 *Self-Portrait*, 1898.

164 Photograph of the Château de Buillon.

than the artist (164). In the Moffett article Tissot described his life at Buillon in typically pious tones:

> So, for weeks at a time, I withdraw from Paris to a wonderful lonely valley, shaped like a vast amphitheatre, where the wind blows always and a little river runs. This is one of Nature's worship spots, where reverence is in the air. Hundreds of years ago godly men chose this place for a monastery, and on the ruins of their buildings I have made my home for contemplation. Ah, the days that I have spent there listening to the wind sigh and watching the river flow!

165 *The Camp before Sinai*, 1889–1901.

In fact, Tissot's life there was far from monastic. He lived in considerable style, surrounded by servants and relations, in particular his niece, Jeanne Tissot, to whom he was to leave the château and its contents. Photographs of the château show a plain but handsome edifice, in a lovely setting. Tissot made many improvements and embellishments, including building in the grounds a studio in the English style. In Paris too, his house had become very grand, the 'house beautiful' being an indispensable attribute of the successful nineteenth-century artist. A contemporary description of his studio by George Bastard reminds one of similarly grandiose artistic interiors in London, such as Lord Leighton's house in Holland Park:

> It was there that the artist, having looked about and noted everything with due care, sat down to his canvases lit by the great bay-windows of his spacious studio, decorated with hangings and flags attached above as to the vault of some palace; [it was] a vast, luminous hall, invaded by plants, decorated with vases and bronzes, where floating materials in a brilliant range of colours played, blending among each other in vibrant hues over a jumble of furniture of every style ...

Like so many successful artists of the time, Tissot had confused being an artist with being merely artistic. But greater challenges lay ahead. After the great success of the *Life of Christ*, he determined to illustrate the Old Testament as well. A final trip to the Holy Land was undertaken in 1896, to gather more material. On the ship out his presence was noted by an English artist, G.P. Jacomb-Hood, and recalled in his memoirs *With Brush and Pencil* (1925).

> On the ship I found a very interesting traveller in the person of James Tissot, who was returning to Palestine to continue his wonderful series of illustrations of the Bible, to which he was devoting what remained of his life. Tissot, a very neatly dressed, elegant figure, with a grey military moustache and beard, always appeared on deck gloved and groomed as if for the boulevard ...

Jacomb-Hood also recalled Tissot's London period, 'where he painted pictures of *mondaines* and *demi-mondaines* under sunlit chestnut trees etc. ... full of delicate colour, and with a subtle touch ... Then, I believe, a woman to whom he was devoted, died, and he "got religion" and gave himself entirely to his work in Palestine.' Later Jacomb-Hood visited Tissot in Paris, and found him still working unceasingly on his Palestine drawings.

Tissot never lived to see the publication of his Old Testament series, but before his death in 1902 he completed ninety-five of the illustrations. These

were exhibited at the Salon du Champ-de-Mars in 1901. After his death the illustrations were completed either from his sketches or in his style by six different studio assistants. Publication in French, English and American editions took place in 1904. Tissot's own originals also toured the U.S.A. and were eventually purchased by the New York Public Library, which later passed them to the Jewish Museum. The religious climate had already changed to such a degree that the second set attracted practically no attention at all. Like their predecessors, they are all in watercolour and body colour, and those executed by Tissot are all of the Book of Genesis. The realistic and mystical approach is much the same as the *Life of Jesus* series, but as there are no Passion scenes, the majority are simply narrative and topographical material, and are therefore more palatable to modern taste. Scenes like *The Camp before Sinai* (165) are extremely striking; others such as *Abraham's Servant meeteth Rebecca* (167) and *Moses laid amid the Flags* (169) can be appreciated simply as so much French orientalism, or *'bédouinage'* as de Goncourt called it. With *Jacob's Dream* (170) we are back with the pseudo-mystical, but *The Plague of Locusts* (168) does have a powerful, almost hallucinatory quality.

After about 1900, Tissot spent most of his time at Buillon, working to the end on his Old Testament drawings. Much of his time was devoted to improving the house and its grounds, adding rose arbours, ruins and lakes. It was while supervising the construction of an ornamental pool that he caught a chill and died, on 8 August 1902. In his will he offered the *Prodigal Son* set to the Louvre; the gift was refused, and the pictures passed instead to the museum in his home town of Nantes. Tissot's reputation was already in

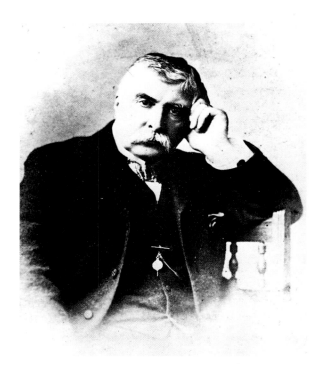

166 Photograph of Tissot in old age, *c*1895.

167 *Abraham's Servant meeteth Rebecca*, 1889–1901.

168 *The Plague of Locusts*, 1889–1901.

decline; oblivion was to follow. His studio sale took place in Paris in 1903, when both pictures and prints sold for derisory prices. The last, flickering manifestation of his once great renown was an obsure Pathé film of the Passion, made in 1912, and based on his Bible illustrations. D.W. Griffith also used Tissot's Bible for settings and costumes in his great film *Intolerance*. So, like Alma-Tadema, whose pictures were also used by Griffith and Cecil B. de Mille, Tissot's final, unlikely apotheosis was in the twentieth-century cinema.

169 *Moses laid amid the Flags*, 1889–1901.

170 *Jacob's Dream*, 1889–1901.

169

170

155

List of Illustrations

Select Bibliography

The most complete bibliography is to be found in Michael Wentworth *James Tissot*, Oxford University Press, 1984, pp 209–17. The following is a select list of the more important books, catalogues and articles, including those referred to in this book.

Periodicals etc.

Art Journal, Royal Academy and Grosvenor Gallery reviews, 1872–7

Athenaeum, Royal Academy and Grosvenor Gallery reviews, 1864–1902

Graphic, Royal Academy and other reviews, 1873–77

Illustrated London News, Royal Academy and Dudley Gallery reviews, 1872–82

Magazine of Art, Grosvenor Gallery, 1878, p 82

Portfolio, no. 193 (Jan. 1886), pp 143–4

Punch, Grosvenor Gallery review, 21 June 1879, pp 285–7

Spectator, Royal Academy, Grosvenor Gallery and other reviews, 1864–1881

The Times, Royal Academy and Grosvenor Gallery reviews, 1872–9 (detailed list in Wentworth)

Books, Catalogues etc.

AMAYA, MARIO, 'The Painter of La Mystérieuse' *Apollo*, no 77 (August 1962), pp 472–4

BASTARD, GEORGE, 'James Tissot', *Revue de Bretagne*, 2nd ser. 36 (November 1906), pp 253–78

BAUDELAIRE, CHARLES, *Art in Paris 1845–62*, Phaidon 1965

BERALDI, HENRI, *Les Graveurs du XIX siècle: guide de l'amateur d'estampes modernes*, vol 12, pp 125–34, Paris 1892

BLANCHE, JACQUES-EMILE, *Portraits of a Lifetime*. ed. and tr. Walter Clement, New York 1938

BOWLES, THOMAS GIBSON, *The Defence of Paris: Narrated As It Was Seen*, London 1871 (illustations by Tissot)

BROOKE, DAVID S., WENTWORTH, MICHAEL, AND ZERNER, HENRI, *J.J. Tissot: A Retrospective Exhibition*. Providence: Museum of Art, Rhode Island School, and Art Gallery of Ontario, Toronto 1968

BROOKE, DAVID S., 'James Tissot and the "Ravissante Irlandaise"', *Connoisseur*, 168 (May 1968), pp 55–9 (other articles by David Brooke listed in Wentworth)

BURNE-JONES, GEORGIANA, *Memorials of Edward Burne-Jones*, 2 vols, London 1904

DU CAMP, MAXIME, *Les Beaux-Arts à l'Exposition Universelle et aux Salons de 1863–7*, Paris 1867

CARR, J. COMYNS, *Coasting Bohemia*, London 1914

CLARETIE, JULES, 'M. James Tissot', *Peintres et Sculpteurs contemporains*, Paris 1873

DEGAS, EDGAR, *Degas Letters*, ed. Marcel Guérin and tr. Marguerite Kay, Oxford 1948

FARMER, JOHN S., 'Twixt two Worlds: A Narrative of the Life of William Eglinton*, London 1886

DE GONCOURT, EDMOND AND JULES, *Journal: mémoires de la vie littéraire*, Paris 1956

JAMES, HENRY, 'The Picture Season in London, 1877' *Galaxy* (August 1877), repr. in *The Painter's Eye* etc., Harvard 1956, pp 130–51

JOPLING, LOUISE, *Twenty Years of My Life*, London 1925

LAVER, JAMES, *Vulgar Society: The Romantic Career of James Tissot*, London 1936

DE LOSTALOT, ALFRED, 'James Tissot', *Society of French Watercolourists*, Paris 1883

MAAS, JEREMY, *Victorian Painters*, London 1969

MATYJASZKIEWICZ, KRYSTYNA (ed.) *James Tissot Exhibition*, Phaidon Press and Barbican Art Gallery, 1984 (essays by Sir Michael Levey, Michael Wentworth, Jane Abdy, Ian Thomson and others)

MISFELDT, WILLARD E., *J.J. Tissot: A Bio-Critical Study*, Ann Arbor 1971

MITCHELL, PETER, *Alfred Emile Leopold Stevens*, London 1973

MOFFETT, CLEVELAND, 'J.J. Tissot and his Paintings of the Life of Christ', *McClure's Magazine*, 12 (March 1899), pp 386–96

NAYLOR, LEONARD, *The Irrepressible Victorian: The Story of Thomas Gibson Bowles*, London 1965

PENNELL, ELIZABETH R. AND JOSEPH, *The Life of James McNeill Whistler*, London 1902

PEARSALL, RONALD, *The Table Rappers*, New York 1972

REYNOLDS, GRAHAM, *Painters of the Victorian Scene*, London 1953

ROSS, MARITA, 'The Truth about Tissot', *Everybody's Weekly*, 15 June 1946, pp 6–7

SCHIFF, GERT, 'Tissot's Illustrations for the Hebrew Bible', catalogue of Exhibition of Tissot's Bible illustrations, Jewish Museum, New York 1982

SHERARD, ROBERT, 'James Tissot and his life of Christ' *Magazine of Art*, 18 (1895), pp 1–8

SITWELL, SACHEVERELL, *Narrative Pictures: A Survey of English Genre and its Painters*, London 1937

SUTTON, DENYS, *Nocturne: The Life of James McNeill Whistler*, New York 1964

THOMSON, IAN, 'Tissot's Enigmatic Signatures', *Gazette des Beaux-Arts*, May 1985

WARD, LESLIE, *Forty Years of 'Spy'*, London 1915

WENTWORTH, MICHAEL, *James Tissot: Catalogue Raisonné of his Prints*, Minneapolis 1978

James Tissot, Oxford 1984

WILDE, OSCAR, 'The Grosvenor Gallery 1877', repr. in *The First Collected Edition of the Works of Oscar Wilde*, 15 vols, ed. R. Ross, London 1969, vol. 15, pp 5–23

WOOD, CHRISTOPHER, *Victorian Panorama – Paintings of Victorian Life*, London 1976

Index